SUSUMU SHINGU

Shingu

Photographs by Yukio Futagawa

Introduction by Edward F. Fry Commentary by Takahiko Okada

Harry N. Abrams, Inc., Publishers, New York

Translated by Richard Gage
Book design by Hideaki Murase and Taku Ikeda

Standard Book Number: 8109-0481-0
Library of Congress Catalogue Card Number: 72–3684
All rights reserved. No part of the contents of this book may be
reproduced without the written permission of the publishers,
Harry N. Abrams, Incorporated, New York
Printed and bound in Japan

CONTENTS

LIST OF PLATES

*Works with colorplates are marked with an asterisk ***

SUSUMU SHINGU

INTRODUCTION

The marvelous combinations of air, water, sound, and movement effected by Susumu Shingu reached a high point in the floating sculptural ensemble which he created for EXPO '70 in Osaka. Previous to that culminating effort, however, the artist had experimented for several years with the subtle problems of wind and water sculpture. By 1967, he had already reached a point in the development of a kinetic style where, in works of medium size, he adapted the organic sculptural metaphors of Alexander Calder to situations incorporating small-scale rapid motion within a larger context of slow movement. Also by 1967, Shingu had become aware of the potentiality for kineticism of water in combination with floating sculpture (for example, *Rudderless Boat*). In this respect his work has had few counterparts in recent years, save possibly for the floating buoylike monuments of the American sculptor Robert Grosvenor. In *Duet* (1968), Shingu for the first time reached a satisfactory fusion of hydraulics and motion.

Shingu's capacity for introducing wit and humor into his kinetic work is nowhere more apparent than in his *Stroll on Clouds* (1968), in which driver vanes rotate about a central axis supported by bicycle wheels rolling in a circular path on the ground. But while Shingu was developing the general capabilities of his kinetic approach, he also found a suitable use for color in conjunction with motion. From 1967 onwards he has integrated movement and color patterns, sometimes, as with *Communication of Plants* (1968), in an overtly Calderesque manner, but more often in an idiom not identifiable with Western sources. Simultaneously, he began to work on a monumental scale; one of the first examples of these two efforts in unison is *Together with the Sun* (1968), a work which stands almost twenty-five feet tall and which was installed at EXPO '70.

It was in 1968 that Shingu was chosen as one of a small group of sculptors to present works at Osaka for EXPO. There he presented a monumental ensemble entitled *Floating Sound*, begun in 1969 and consisting of six huge floating buoys, disposed in a circle upon the waters of an artificial pond at the fairgrounds. Using a simple color scheme of red, yellow, blue, and white, Shingu created an ensemble at once visually arresting and incorporating a preordained program of sound and movement. Smaller kinetic works of this same period, embodying either water, wind, or a combination of the two, marked an extension of Shingu's earlier ideas, nevertheless, an increasing independence from Calder or other Western predecessors was ap-

9

parent, as well as an enhanced ability on the artist's part to execute schemes of ever greater monumentality and sophistication. One of his most notable recent air-driven works is *Path of the Wind* (1970), an imposing tower sixty-six feet in height which incorporates not only Shingu's usual three-bladed wind vane but which is also constructed to allow for rotation in all three spatial axes in response to prevailing wind conditions.

It is in another work of 1970, however, that Shingu may have most successfully combined kinetic sculpture with his own Japanese heritage, in a solution which enhances both. On the grounds of Koyodai High School, he created a unified environment of water, landscape, and hydraulically activated sculpture. Rather than depending on color effects or other secondary factors, Shingu in this ensemble has combined an artificial pond, carefully related to its surroundings, with a kinetic sculpture whose movements are generated by constantly flowing fountains. The motions of the sculpture pass through an endless cycle controlled by its own feedback system, while its structure harmonizes with the character of a high school playground area.

The course of Shingu's development thus far reveals him to be one of the very few kinetic artists of serious ability to have appeared in postwar Japan. He has also clearly reached a position of aesthetic independence from his Western sources. Shingu has mastered the problems of combined rapid and slow motion, as well as the utilization of visually effective feedback systems within a kinetic work. His experiments with simultaneous combinations of sound, motion, and color are in themselves highly unusual in contemporary art and worthy of considerable respect. Perhaps the most notable quality in all of Shingu's works, however, is the keen sense of his intention not to dominate nature, in the Western classical manner, but rather to cooperate *with* it, be it represented by wind, water, or a specific physical setting. It is probably through the continued exploration of this symbiotic vein that Shingu will most fully realize his capabilities as an artist.

EDWARD F. FRY

STATEMENT

Two Rhythms

There exist in our life two major rhythms. One is the rhythm of nature which surrounds our life, and the other is the rhythm of our inner existence—the rhythm of our spirit which is in us from the moment of our birth to the moment of our death. The rhythm of nature is great, firm, unforeseeable, and beautiful. It is far beyond our poor imagination and our limited power of perception. The expansion of the universe, the movements among the celestial bodies, the existence of the sun, the rotation of the earth—all of these are profoundly related to our life, and yet they share a rhythm which belongs to an entirely different dimension from our rhythm or sense of time, which are limited by our life-span. Even the most common earthly phenomena, such as wind, rain, snow, clouds and the changes of the seasons, fill us with ever fresh wonders. Even the alternation of night and day, which seems to be a meaningless repetition, does have a delicate, variable rhythm minutely calculated. Waves in the sea, streams in the river, trees and grass swaying in the wind—all of these make us visually feel the rhythm of nature. It is only in this kind of environment that we as well as all the other living creatures on the earth can live.

The rhythm of nature is always greater and swifter than our internal sense of time. And we have never really understood the rhythm of our mother, Nature. What is worse, our modern life is making us lose contact with nature more and more, resulting in various misunderstandings. What is most fearful is that human beings are beginning to value their own importance too highly. It is no use bluffing and confronting the strong and mysterious rhythm of nature, because the consequence is that we not only lose the chance of grasping the essence of this dynamic energy, but become unable to realize the true meaning of our lives.

The only way to be really alive, with our eyes open to nature, is to keep ourselves highly flexible and yet firm, so that we can adapt ourselves to changes. We all have undulating and breathing spirits, which change with our internal growth and with stimuli from the outer world and give each of us a uniquely individual rhythm. For me, this internal rhythm of our spirit is just as mysterious as the rhythm of nature, and seems to be a stream of great depth and amplitude. We must not try to control this rhythm and its amplitude. Instead, we must try to grow so that we may be always aware

11

of the greatness of this free and independent movement and be able to change joyfully. We must not allow ourselves to be made rigid by such one-sided conceptions as achieving a purpose or attaining a goal. Since the true value or meaning is not to be found in what is static and solid, we should place ourselves amidst perpetually flowing rhythm. I think the development of this spiritual rhythm, which will end with "death," is the utmost value each individual possesses. The rhythm of changing nature and the rhythm of beings living in nature—these two rhythms are closely related and delicately intertwined, making various points of contact. If we can really *feel* the rhythm of nature through these points, we can absorb much nourishment for our growth.

Tendency Toward Animal-Nature; Plant-like Existence; Attainment of Pellucidity

It is because I want to prevent us from being self-centered and from having an illusion that our own scale is applicable to everything that I am interested in the rhythm of nature and emphasize the importance of being conscious of its terrible power and of trying to be objective about our inner spiritual rhythm. If we call the state in which we can only think in a self-centered way "animal-like," we may call another state "plant-like" in which we come to a true realization of ourselves through contacts with the rhythm of nature. When our mind can relate itself to flowing nature, our insight will be deepened and extended beyond limitation. And then our spirit will be free from animal-like stubbornness and will be more and more flexible and sensitive. We will come to a realization of universal truths or even go through emotional and spiritual excitements from our contacts with nature. That is, we will be able to gather our thoughts and concepts from outside ourselves. If only we are ready, the energy can be an ignition point for our contact with nature. We should listen, observe, concentrate, try to increase points of contact, and create. In order to "create" in the pure sense of the word, we must be free from everything; even we ourselves should not interfere with the act of creation. We must leave everything in the hands of nature. Then we shall be transparent in nature and our individual wills shall not exist any longer.

Nature and Plastic

I have tried to make contact with nature by creating works right in nature. This brings up the contrast of the power of nature and what a man can create —a very definite and cruel confrontation. We see that the architecture, sculp-

ture, and earthenware our predecessors made are getting weathered after centuries of exposure to the sun and the wind. The energy behind this wearing away is slow and steady beyond our imagination but is always acting in one way, that is, it tries to bring the created back to nature. When I see created things, having been released from men's hands, try to return to earth, stone, or the wind, I see man's selfishness being purged and purified by the power of nature. One of the reasons why we should not forget nature in our act of creation is that what we create will always try to go back to nature. This is as definite and sure as man's mortality. And yet, this very mortality of our works and of our life touches them with a striking beauty.

We should not create with too much self-confidence or self-conceit but in modesty, standing firmly on a true understanding of nature and our environment. Our works are in a way our interpretations of nature, so what we create is what nature wants us to create. And because we are only mediums of nature's creation, what is thus created exists in nature with true vitality. We should cultivate in ourselves a sharp and rich sensitivity, free from any preoccupation—a sensitivity that empathizes with nature. Then we can create with real freedom out of the natural elements given to us. Thus, we are at last truly free from our professional preoccupations about what to create and with what techniques . . .

Susumu Shingu

BIOGRAPHICAL OUTLINE

1937 Born July 13, in Osaka, Japan.

1956 Entered Tokyo University of Arts.

1957 First one-man show of paintings at Saegusa Gallery, Tokyo.

1960 Graduated from university, having specialized in oil painting, which he studied under Ryohei Koiso. Married Megumi Ishikawa in August. Went to Rome on a scholarship from the Italian Government and entered Gentilini's class in the Faculty of Painting at the Accademia di Belle Arti.

1962 Graduated from the Accademia.

1963 One-man show at Galleria del Cavallino, Venice.

1964 One-man show at Galerie Tao, Vienna. Joint Exhibition at Galleria Liguria, Rome.

1965 One-man show at Galleria Zero, Verona. Joint Exhibition at Galerie Senatore, Stuttgart.

1966 First presentation of three-dimensional works at Galleria Blu, Milan. His painting style had evolved to include shaped-canvas works and three-dimensional light structures reminiscent of Japanese lanterns. Became acquainted with Kageki Minami, president of Osaka Shipbuilding Company. Returned to Japan in November.

1967 Accepted an offer from Mr. Minami to establish a workshop in the dockyard of the Osaka Shipbuilding Company. One-man show entitled "Wind Structures" at Shoho Gallery, Osaka and Hibiya Park, Tokyo. Received prize at the Second Contemporary Japanese Sculpture Show, opened at the Ube Open-Air Art Museum.

1968 Chosen as one of eight sculptors to present works at EXPO '70 in Osaka. Participated in the Eighth Contemporary Art Exhibition of Japan, Tokyo and Kyoto; Trends in Contemporary Japanese Art, the National Museum of Modern Art, Kyoto; and the Modern Japanese Sculptors' exhibit, Suma Rikyu, Kobe. Also entered the Contemporary Art Exhibition of Japan, held at the Institute of Contemporary Arts, London. Daughter Yuko born in August.

1969 Article in *Time*, January 24, 1969. Created *Floating Sound* for the Lake of Progress at the EXPO '70 site. Entered Ninth Contemporary Art Exhibition of Japan, Tokyo and Kyoto.

1970 Created *Path of the Wind* at Senri New Town, Suita, Osaka. Daughter Natsuko born in June.

1971 Accepted invitation to be visiting artist at the Carpenter Center for the Visual Arts, Harvard University.

Stroll on Clouds. 1968
Molded plastics, steel, and wood
6′11¹/₂″ × 17′9³/₄″
The Harry N. Abrams Family Collection

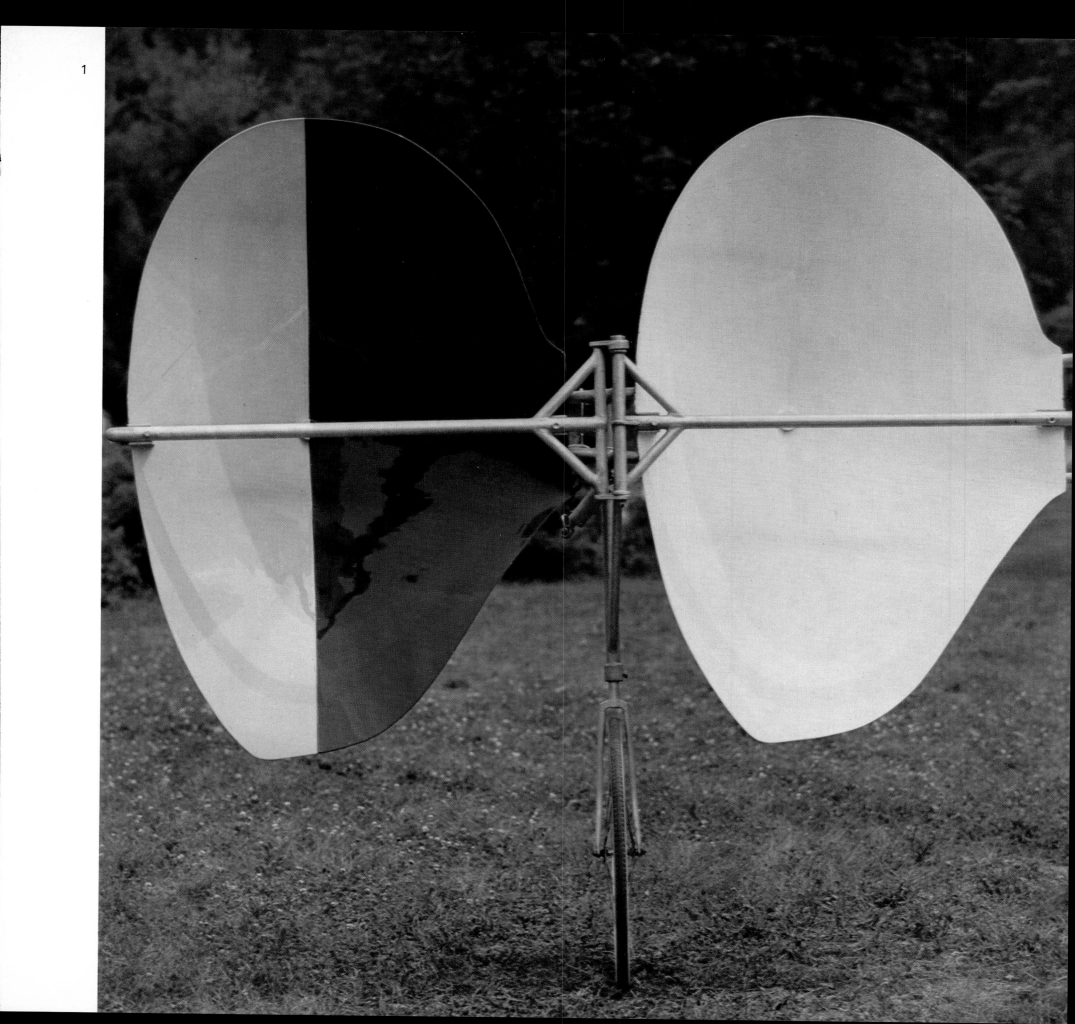

As the name implies, when the great sail-like cups of this work catch the wind, the composition moves in a gentle, almost billowing fashion. Since its motions vary with the changing strength of the wind, the piece is inexhaustibly interesting. Although the resulting elements of change and appeal are common to all of Shingu's works, *Stroll on Clouds* impresses the viewer in a slightly different way for the following reasons. First, the entire symmetrically balanced structure moves; sometimes its action is gentle, sometimes powerful and violent. Second, it emits sounds. So fascinating is the sculpture's endless variety of motion that viewers become completely charmed by its elegant strolling.

A view from above reveals a central axis with three branches extending in different directions. To each of these branches are attached two large curved wings and one bicycle wheel. Not only does the central axis rotate, but also the wheels, which as they roll on the ground set the entire construction in motion when they receive propellant force from wind striking the wings. In addition, the wings on the branches are hinged in such a way that when struck by air currents they bend inward. When they move, the wings remind one of an elephant twitching its ears.

The interior mechanism of bearings and hinges enables the structure to transform even gentle breezes into great energy. The total impression of the piece depends on the nature of its movement, which is slow and gentle at times and quick and sudden at others.

Visually, the work is a condensed combination of lines—the steel pipes—and planes—the plastic wings—which creates a refreshing spatial composition.

2

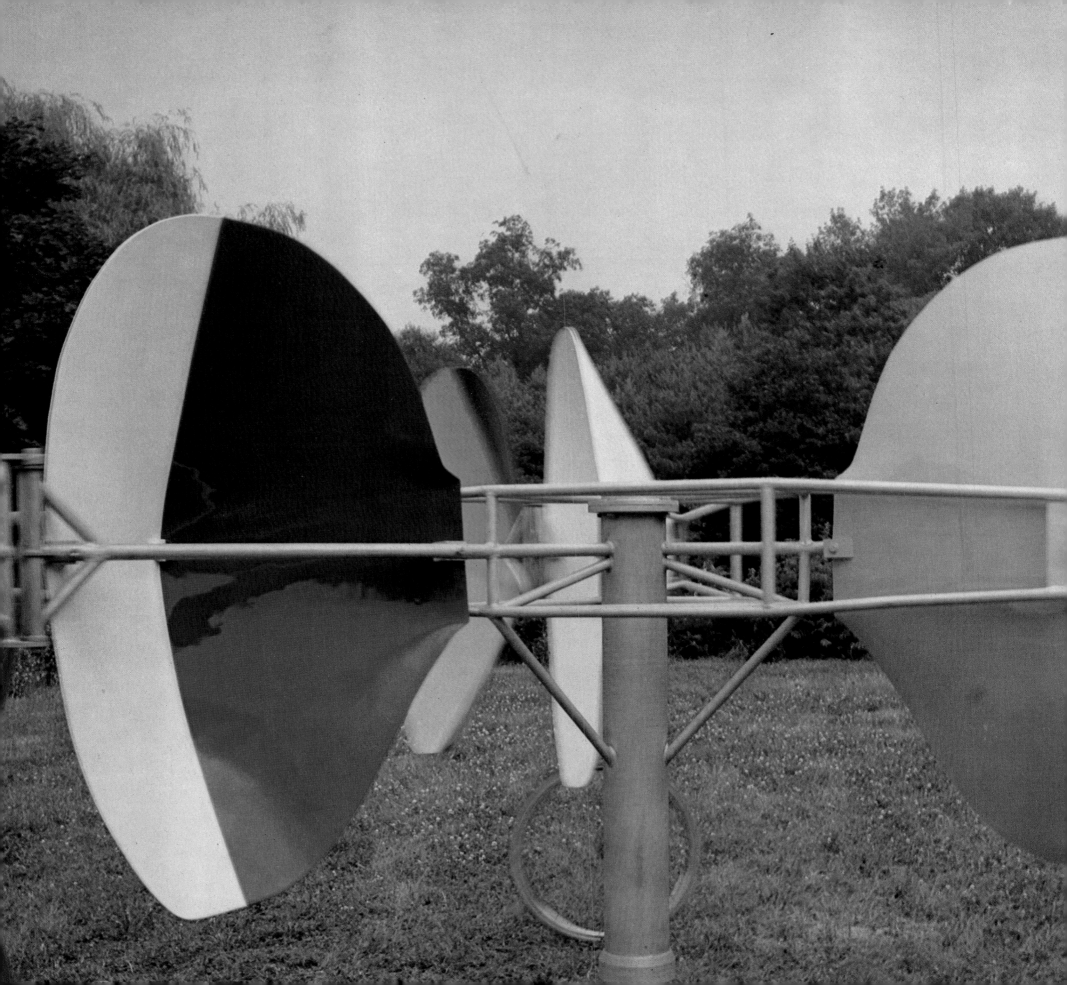

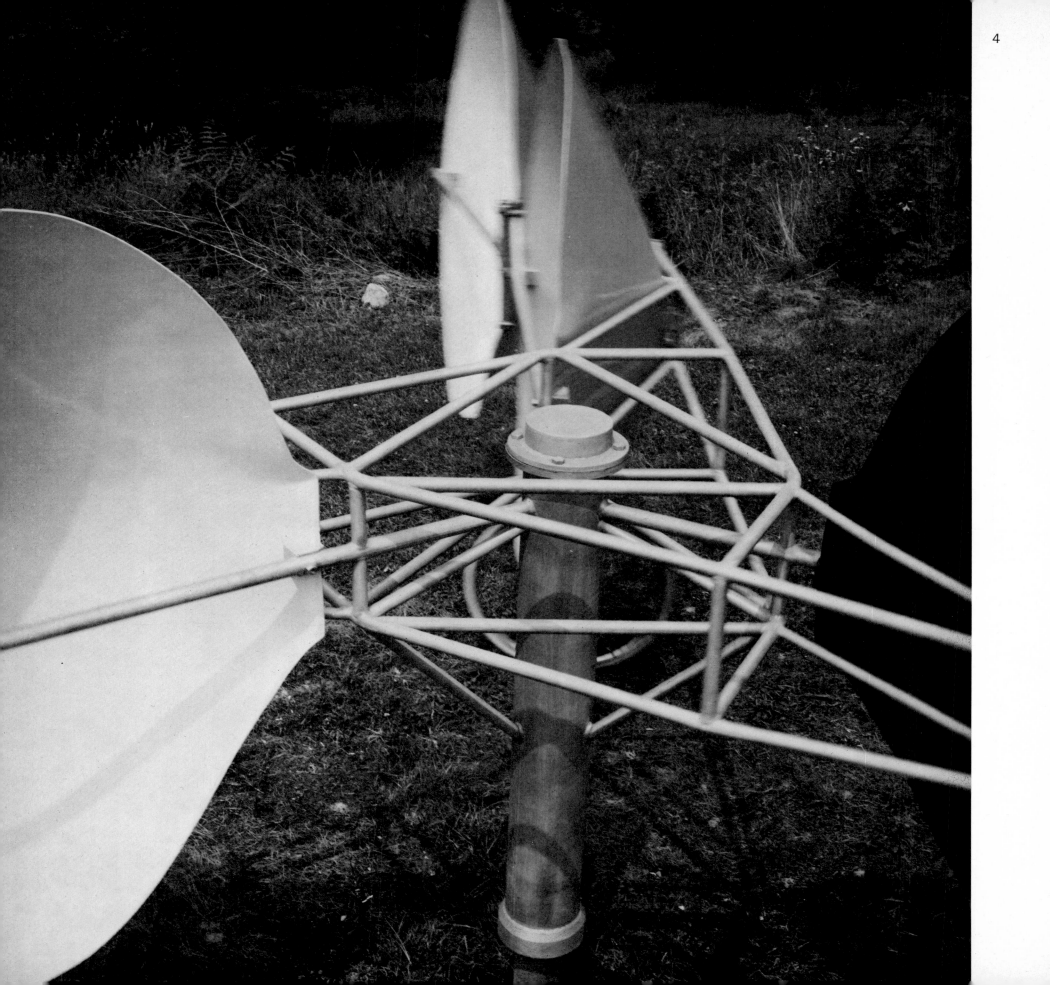

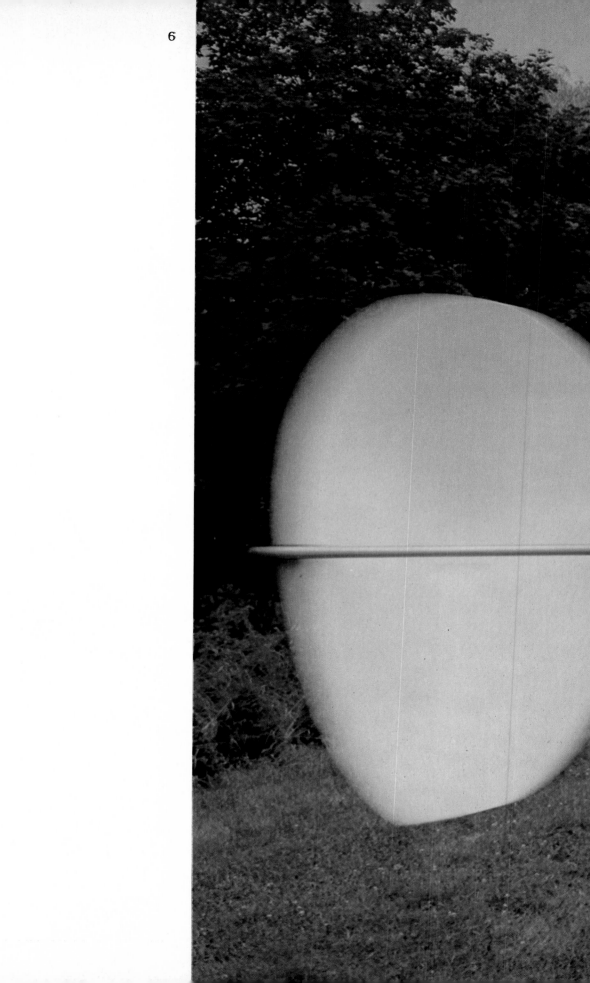

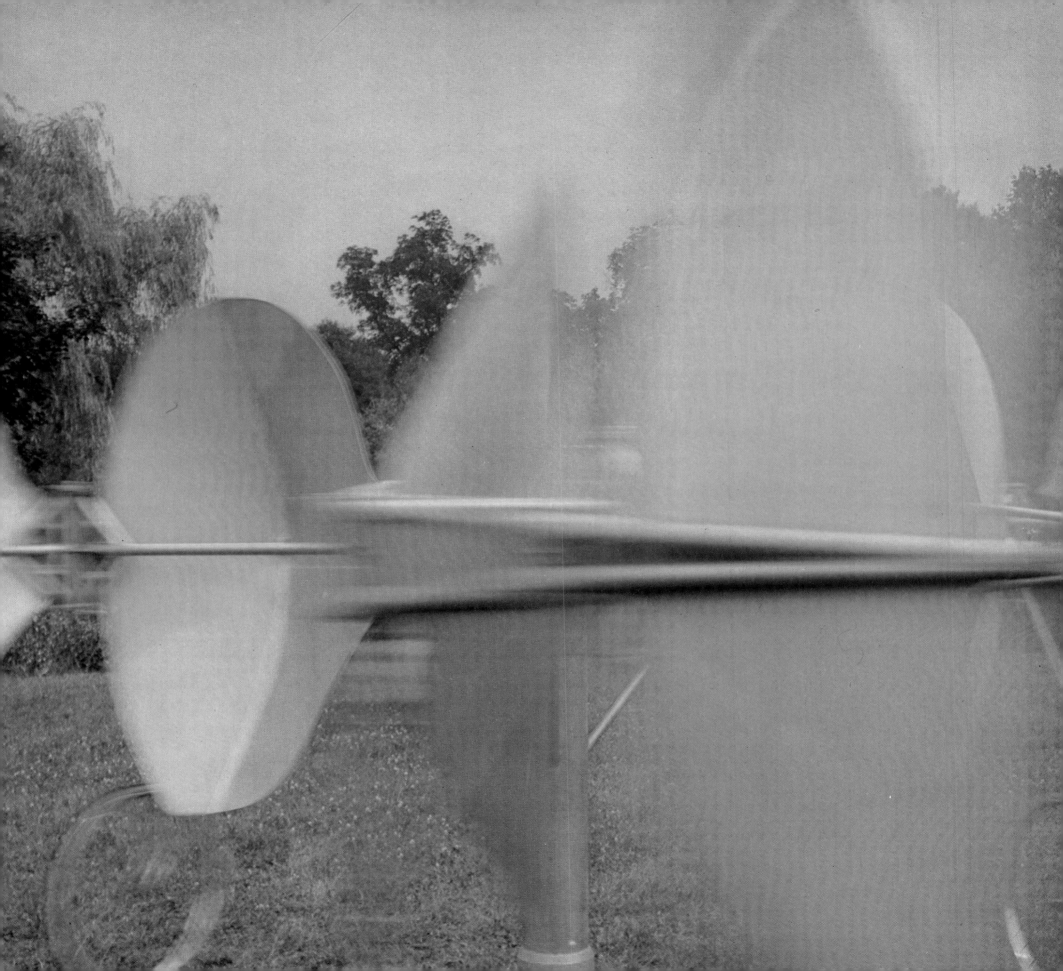

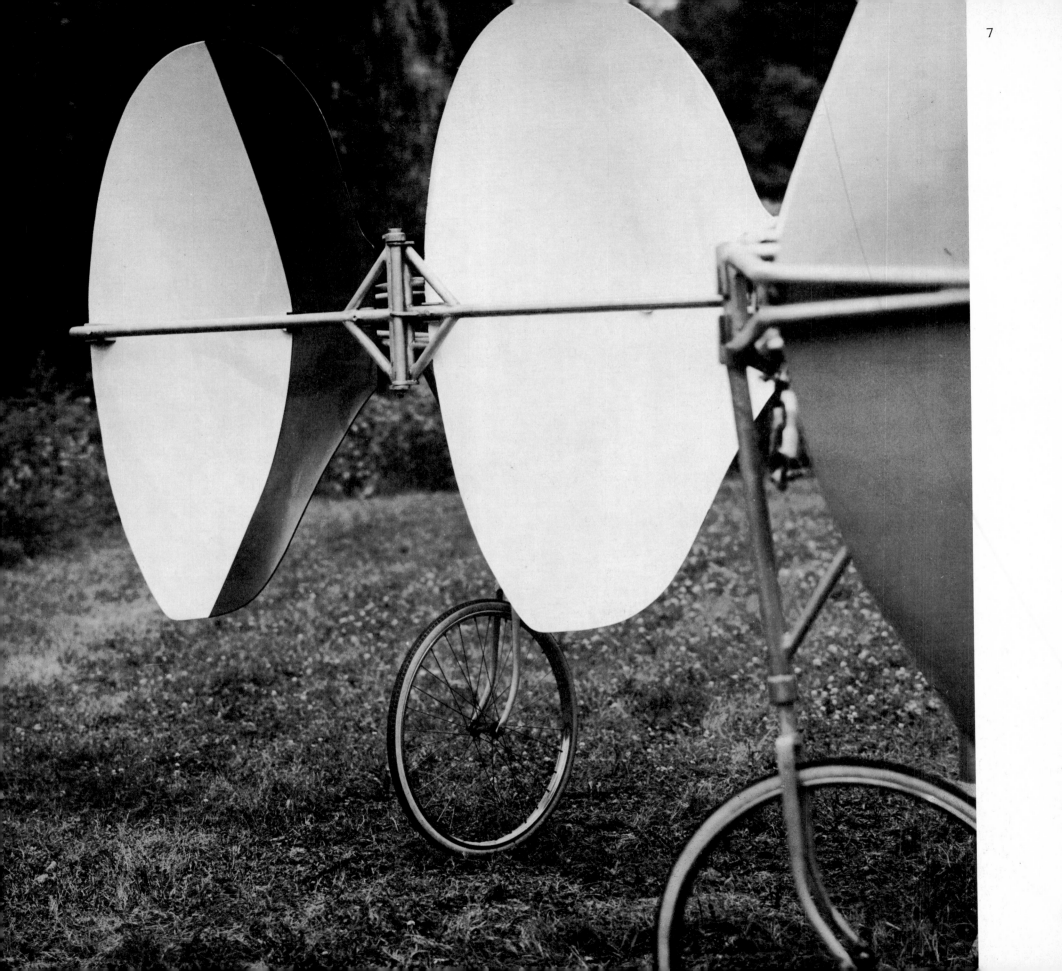

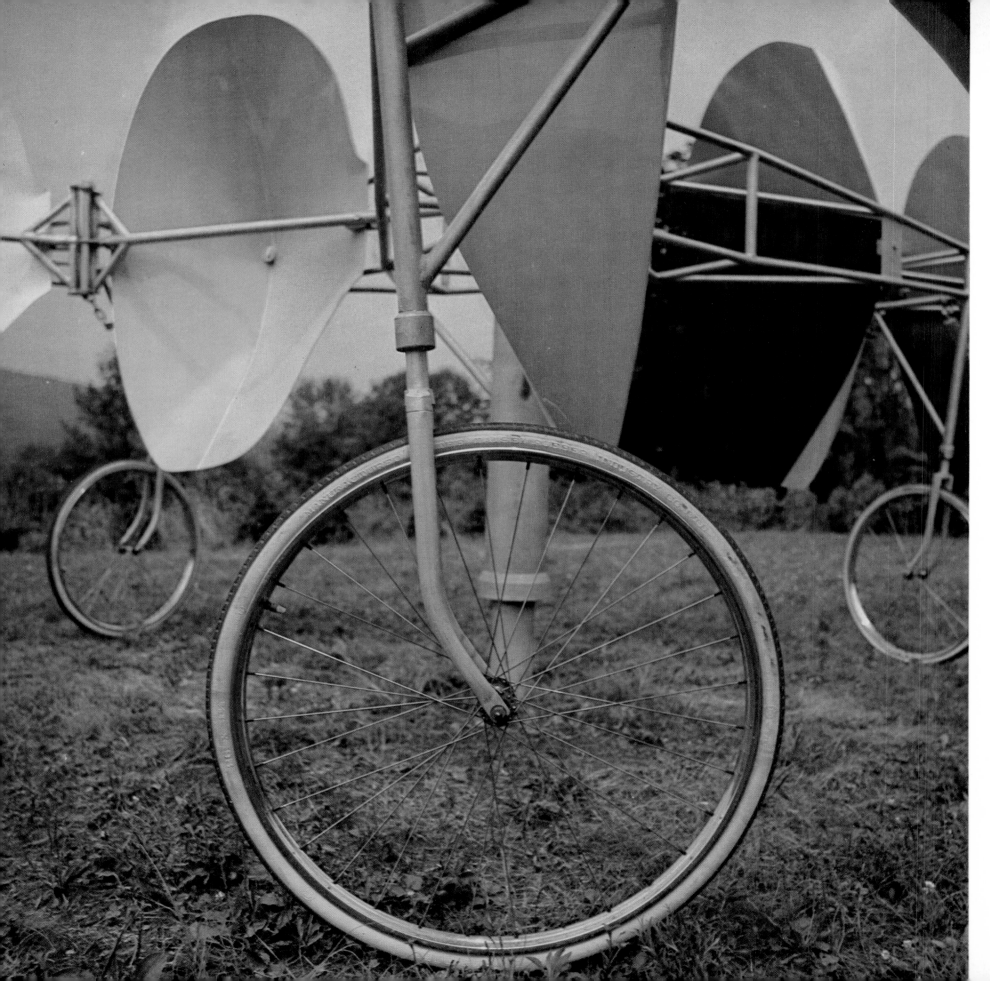

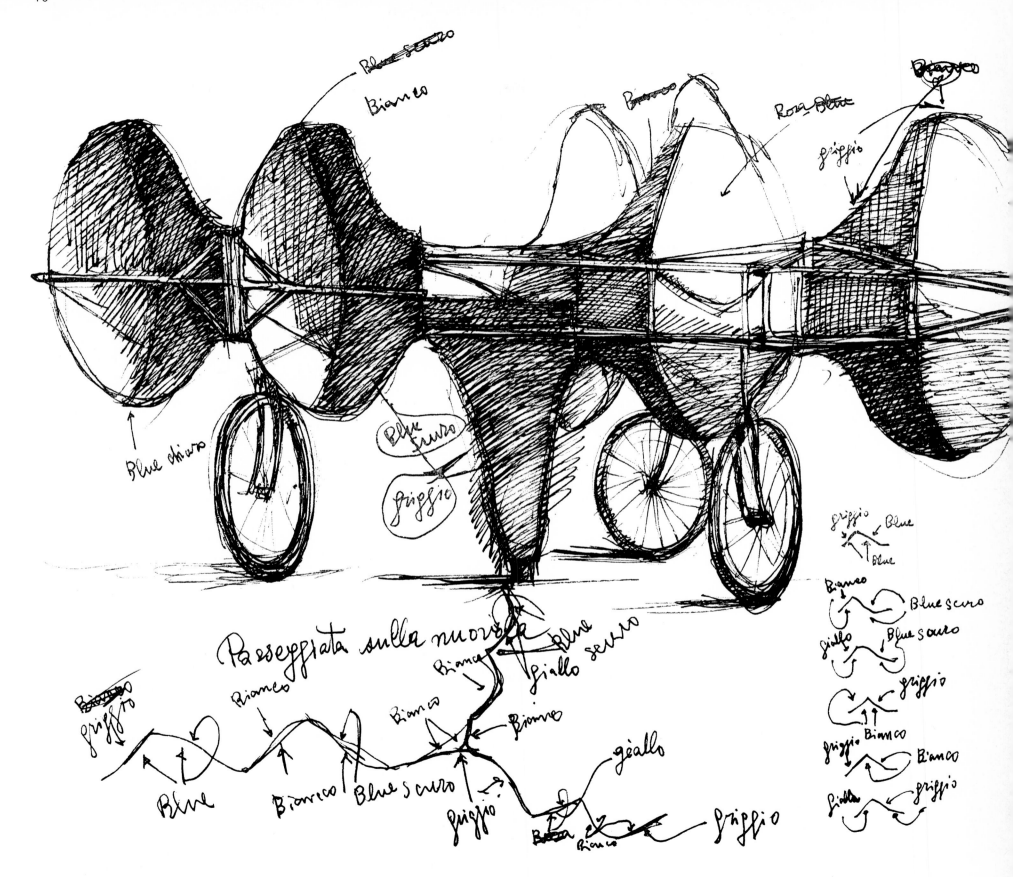

Astral Computer. 1967
Steel, stainless steel, and aluminum
height 5'1 3/4"
Ube Open-Air Museum, Ube, Japan

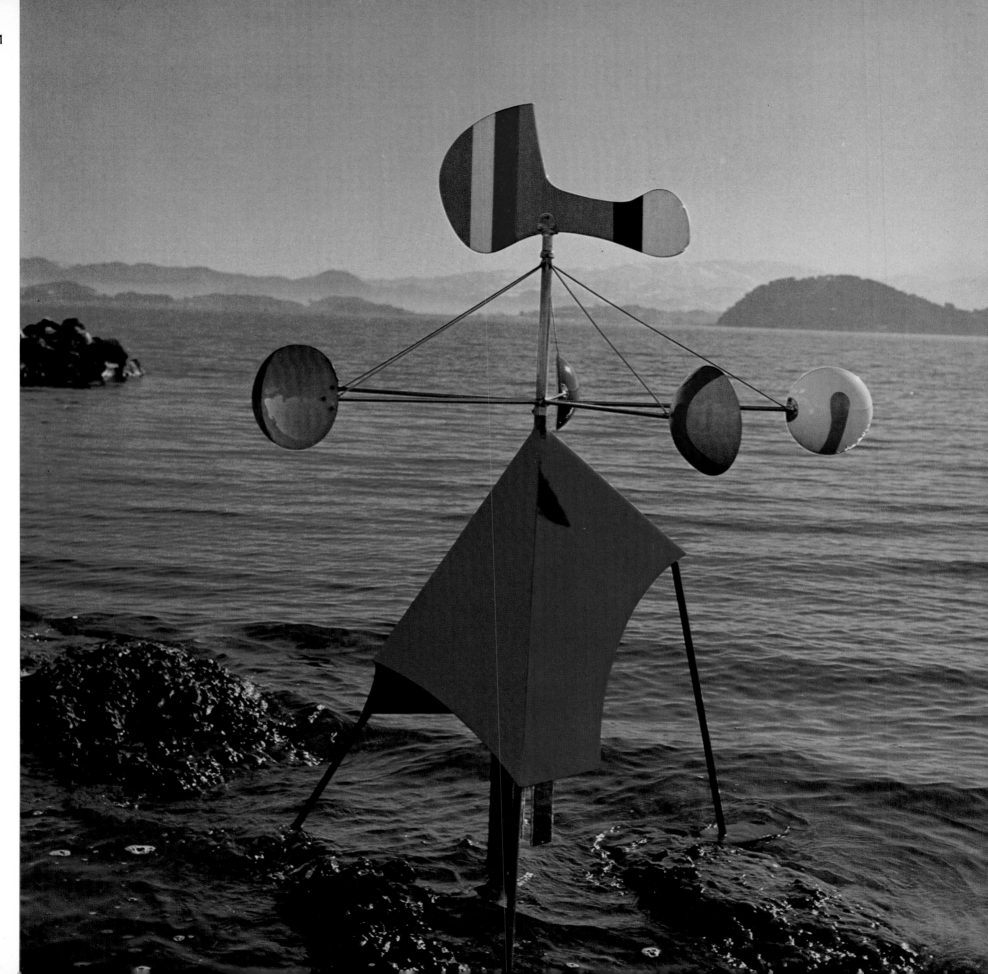

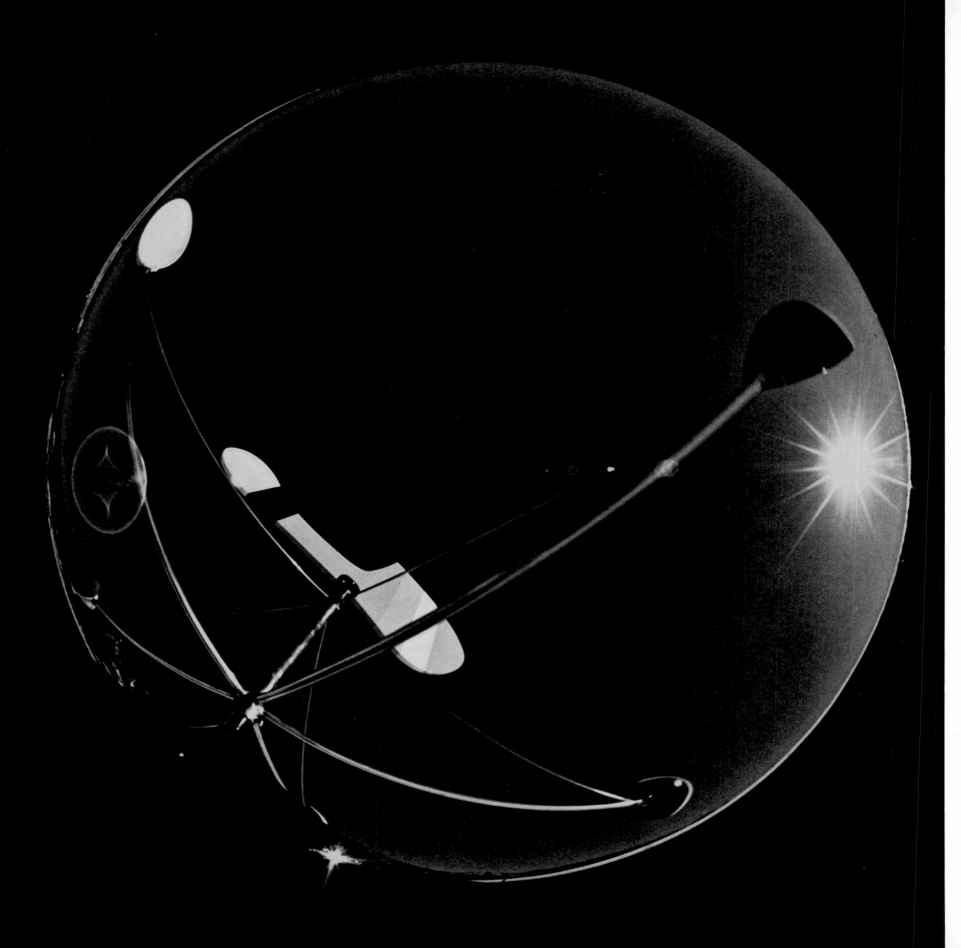

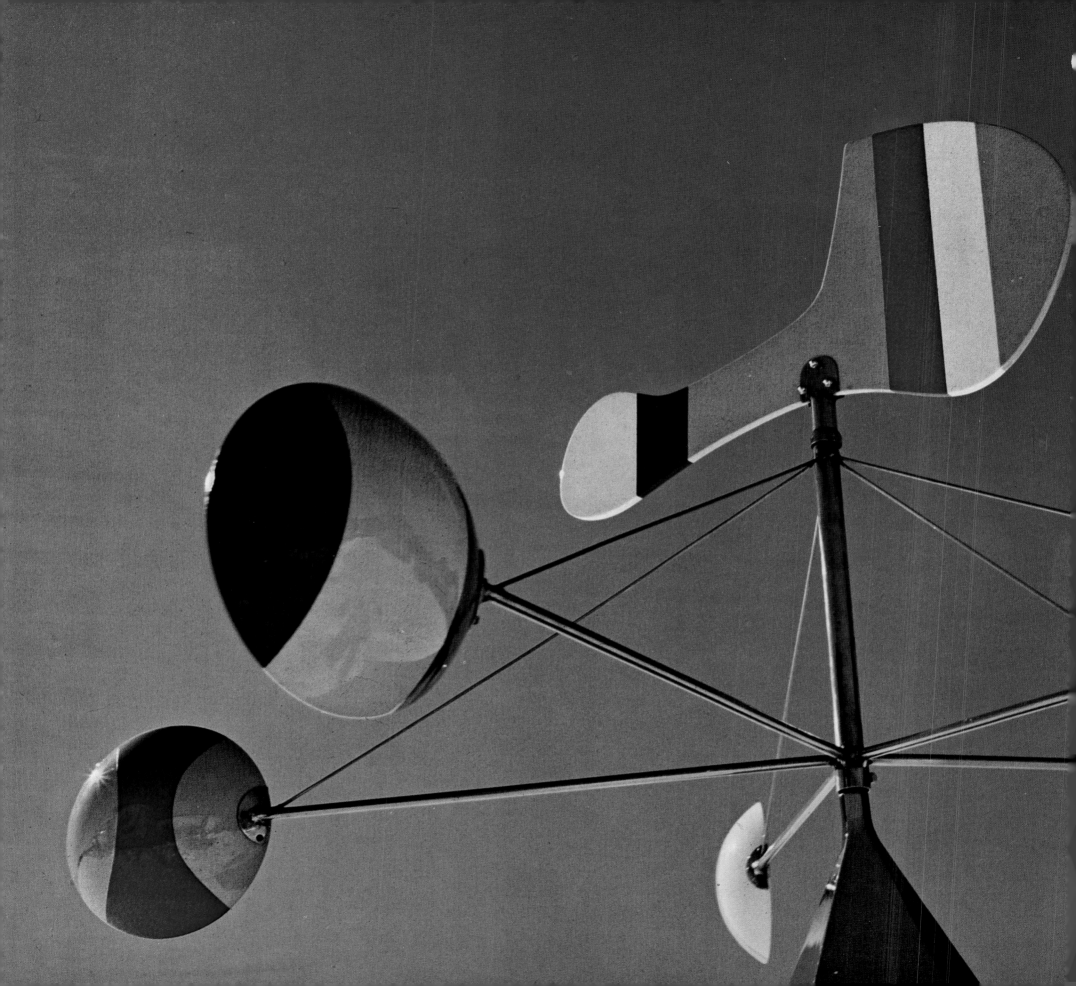

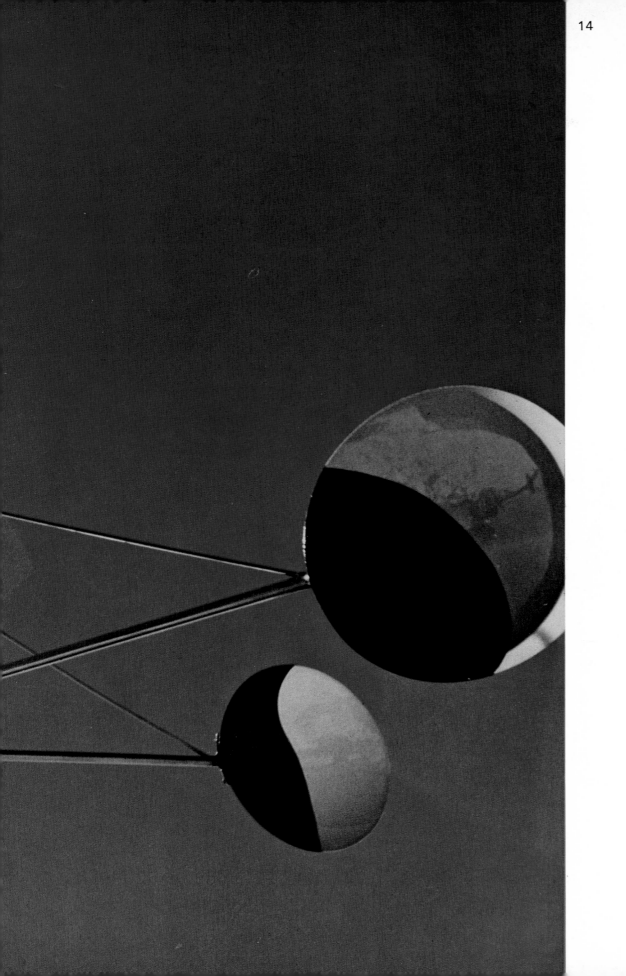

The general construction of this piece resembles a bell tower topped by a weather vane. Below the weather vane are five revolving, wind-catching cups on outstretched arms placed in a star-shaped plan. The lowest section is covered, and within it are suspended stainless steel plates. As the cups turn in the wind they activate a hammer suspended inside the covered area from the axis on which the arms rotate. The hammer strikes the stainless steel plates, which emit a sharp, piercing sound that is softened by the reverberations set up inside the cover. Attached to slender pipes and supported partly by steel cables, the five wind-catching cups, intercepting the breezes with the accuracy of an anemometer, move in an entirely mechanical fashion. This movement, transmitted to the lower section of the sculpture, produces intermittent sounds. In short, an invisible natural force—the wind— is first translated into motion and then intensified as a cool, refreshing sound. In this process lies the principal charm of the work. Equally as skillfully managed, however, is the way the cover, which conceals nearly half of the lower section, divides the sculpture into clearly defined top and bottom parts, thus giving the impression that the two phenomena—motion and sound emission—though based on one kind of energy, belong to entirely different categories.

As is true of Shingu's other works, this sculpture, without intruding the artist's personal emotions on the viewer, exists as clear physical form. It suggests that a lucid spirit fused with nature has been given shape by means of a force that, though part of our surroundings, is invisible. By doing this it inspires a feeling of cosmic harmony in the viewer.

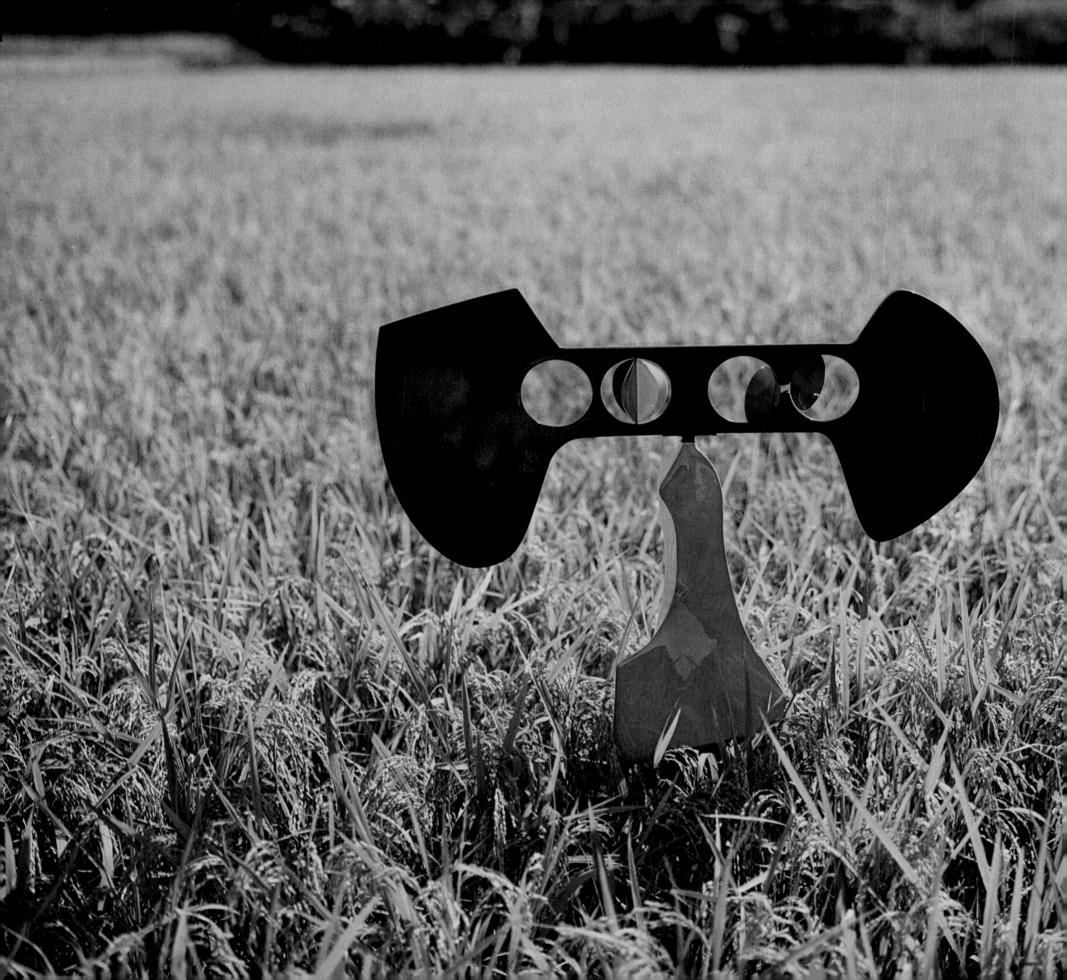

Signal of the Wind. 1967
Molded plastics, steel, and wood
length 32 1/4 "
Private collection, United States

Rudderless Boat. 1967
Molded plastics, steel, and wood
height 41 $^3/_4$ "
Collection the Artist

In *Rudderless Boat*, as in some of his earlier works—*Astral Computer*, for instance—Shingu reveals a basic desire to be free, even if to a limited extent, from the restrictions of gravity. This desire has enabled him to produce constructions that seem to maintain rapport with a cosmic world. Although the viewer can easily detect in *Rudderless Boat* associations with nautical forms and astronomical instruments, it would be a grave mistake to think that all of the artist's ideas spring from a fondness for the sea and for astronomy. Above all Shingu strives to make the work of art itself independent, and in this attempt he employs expressions that, while rejecting ordinary methods of conforming to the laws of gravity, aim at effectively liberating the work of art from all restrictions. Consequently, his forms inevitably resemble shapes that float or are reminiscent of astronomical instruments.

While an initial glance might lead one to dismiss *Rudderless Boat* as a frivolous toy—the actions of intense basic colors, of course, contribute significantly to the work's impression of freshness and naïveté—closer examination reveals it to be a rich spatial expression achieved by means of an extremely simple composition. The swaying of the entire construction when afloat results from subtle movements caused by the wind striking the two cups at one end. This force activates the entire piece, including the central C-shaped section. If it were possible to compare this work with a real boat, one could say that it has two kinds of sails, both of which are subject to the whims of nature.

Floating aimlessly, as its name implies, *Rudderless Boat* expresses the essential freedom of nature by its gentle movement. The adjective "rudderless" may awaken romantic echoes in some minds, but in fact the work is completely free of egocentric romanticism. Instead, it is a well-calculated and well-devised structure that quite unpretentiously leads the viewer into a universal sphere.

Although a small and early work, *Rudderless Boat* is an intense realization of Susumu Shingu's philosophy of forms, namely his conviction that by using simple forms, construction, and colors unexpected new forms will emerge as the sculpture moves.

Prism. 1967
Aluminum, acrylics, and stainless steel
height 12¼″
(three of a series of eighty)

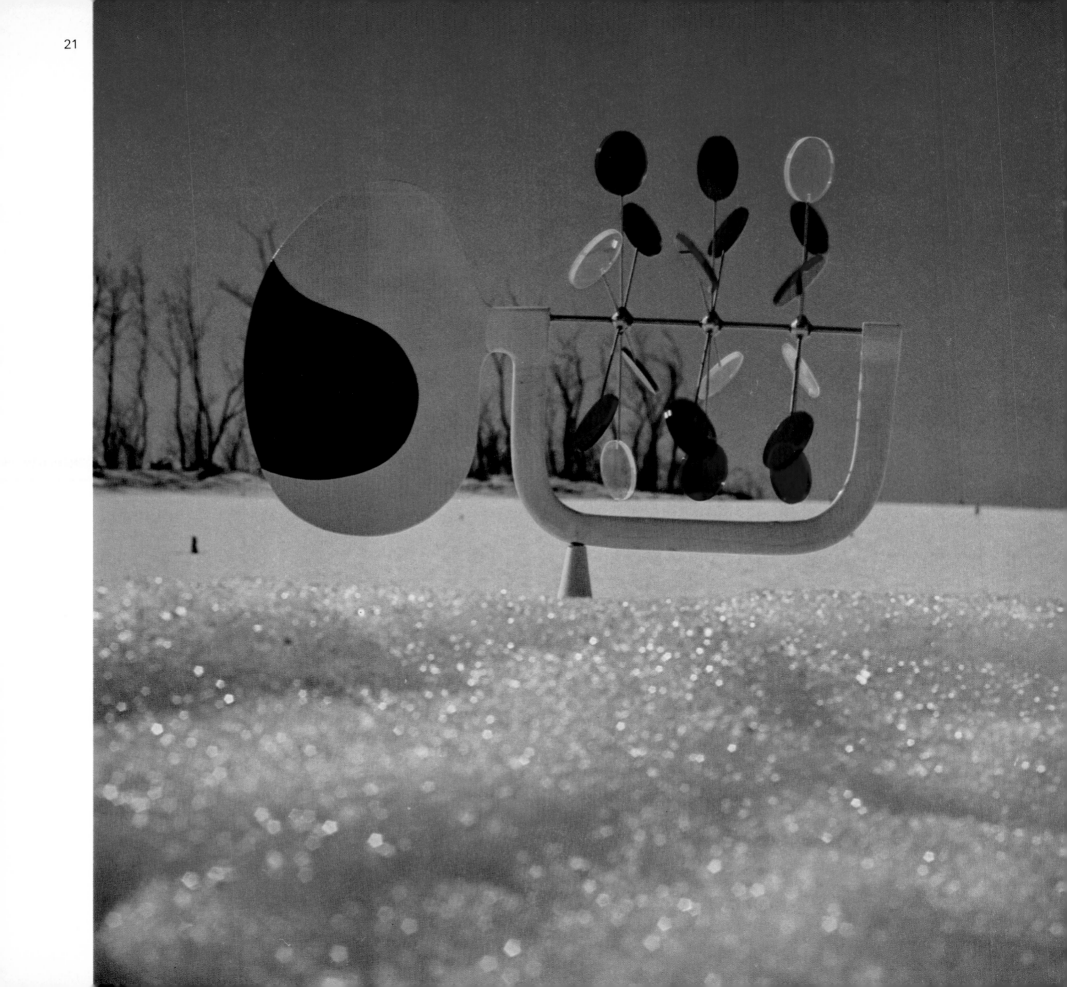

Distant Land. 1968

Molded plastics and steel, height 6′10³/₄″
Science Center for Young People, Kyoto, Japan

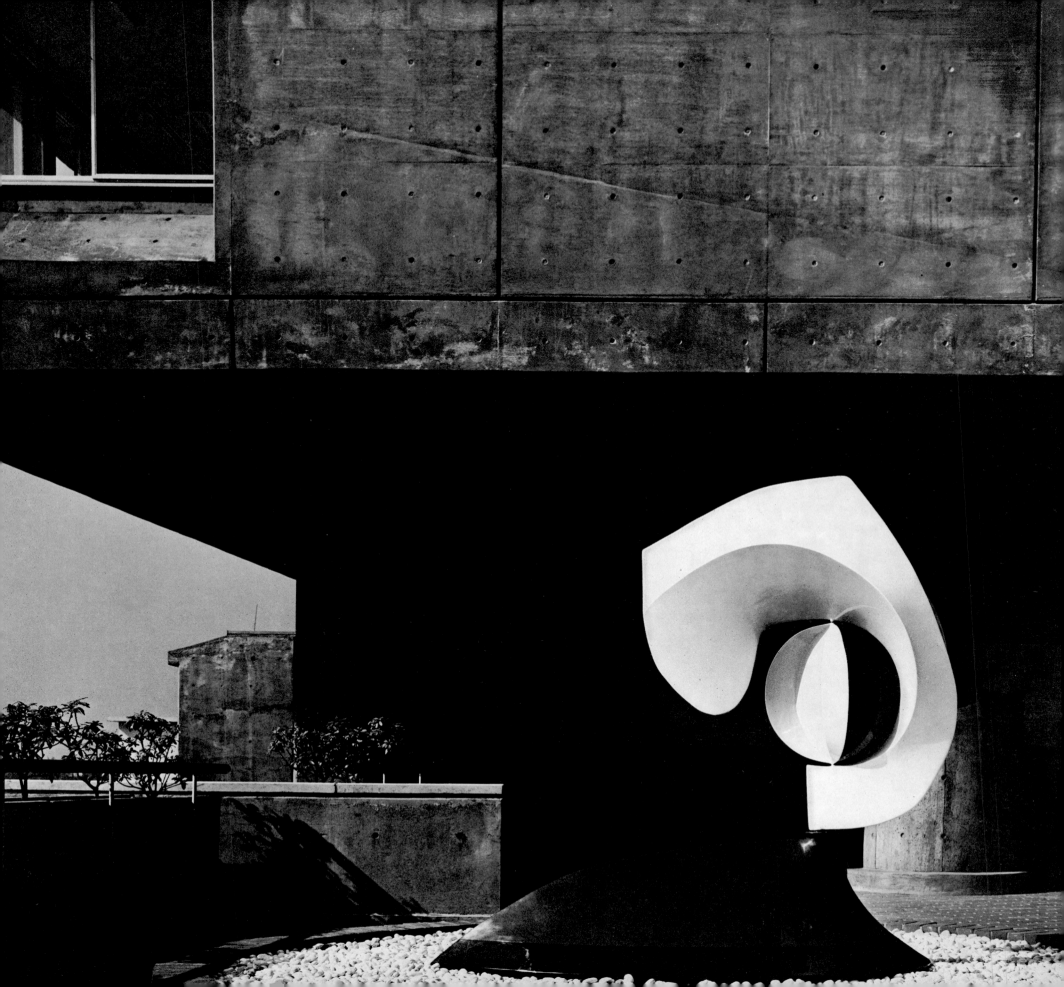

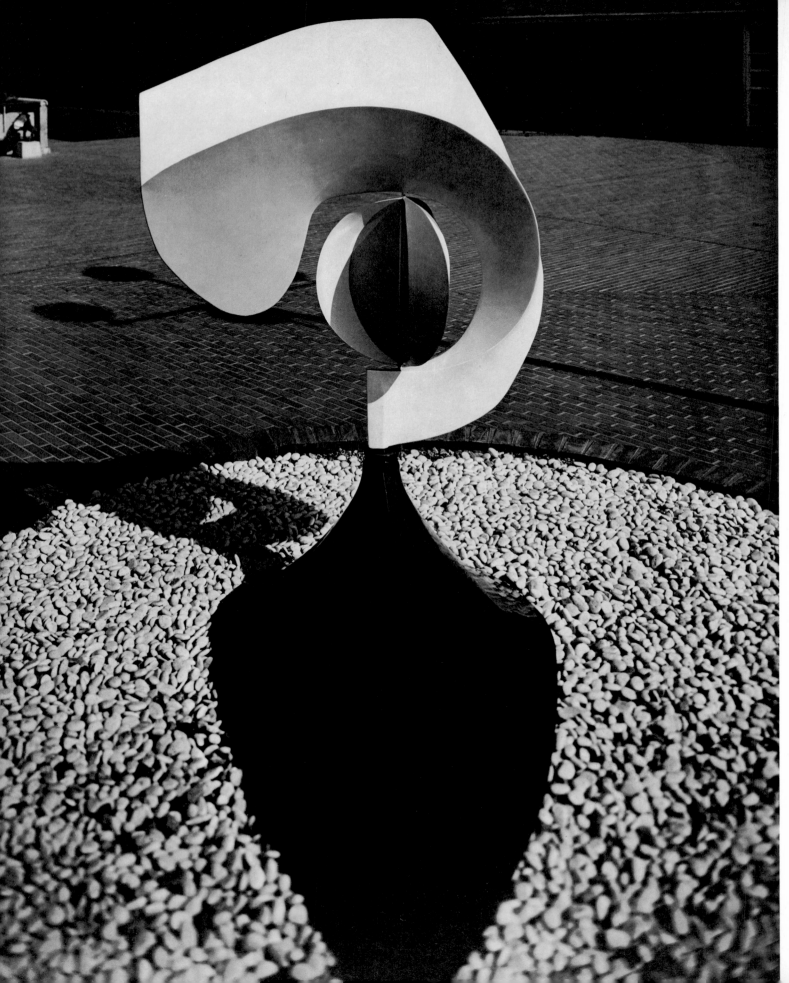

24

15°

70

55

45

160

50

220

Together with the Sun (created for Osaka EXPO '70). 1968
Molded plastics, steel, and stainless steel
height 24′3″
Tachibana Park, Amagasaki City, Japan
(photographed in Wednesday Park at EXPO '70)

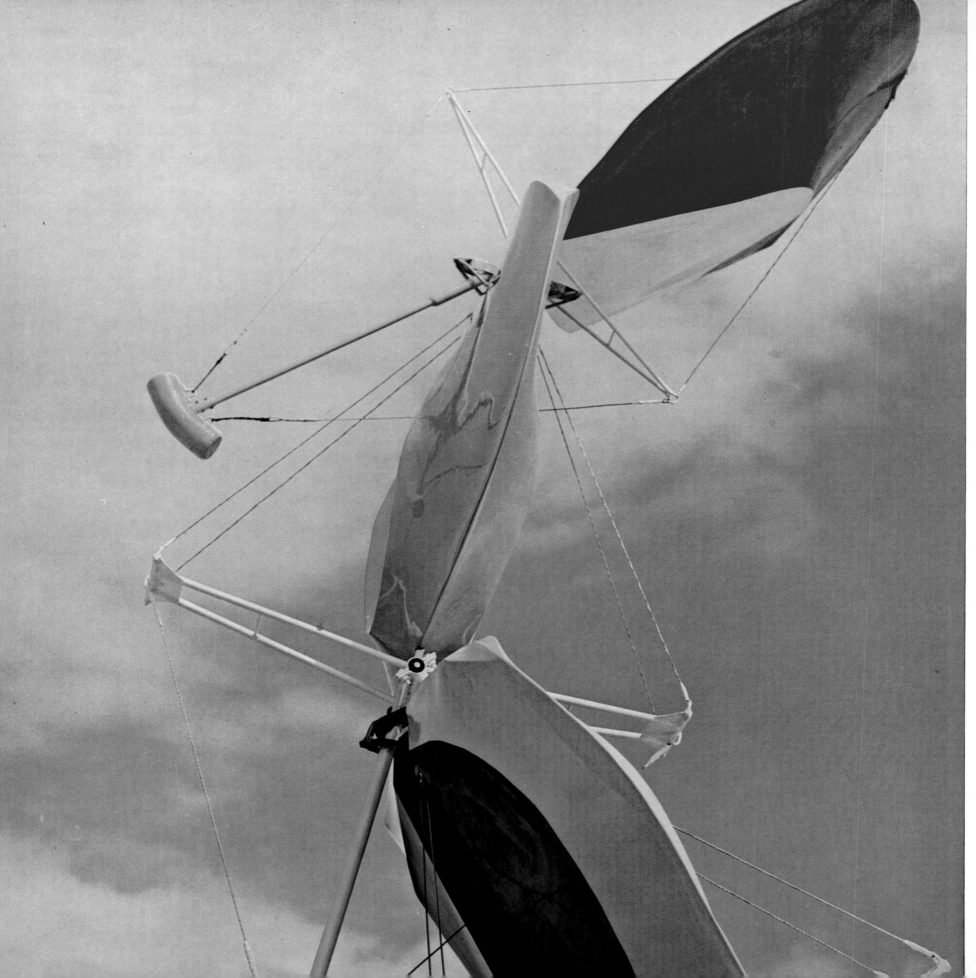

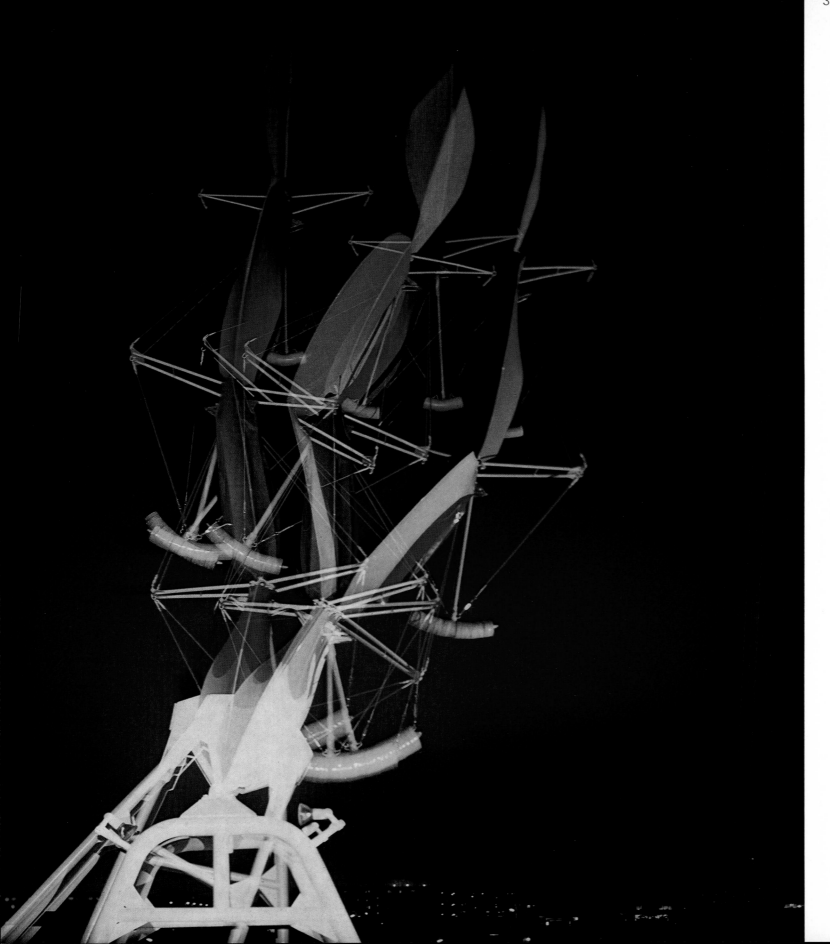

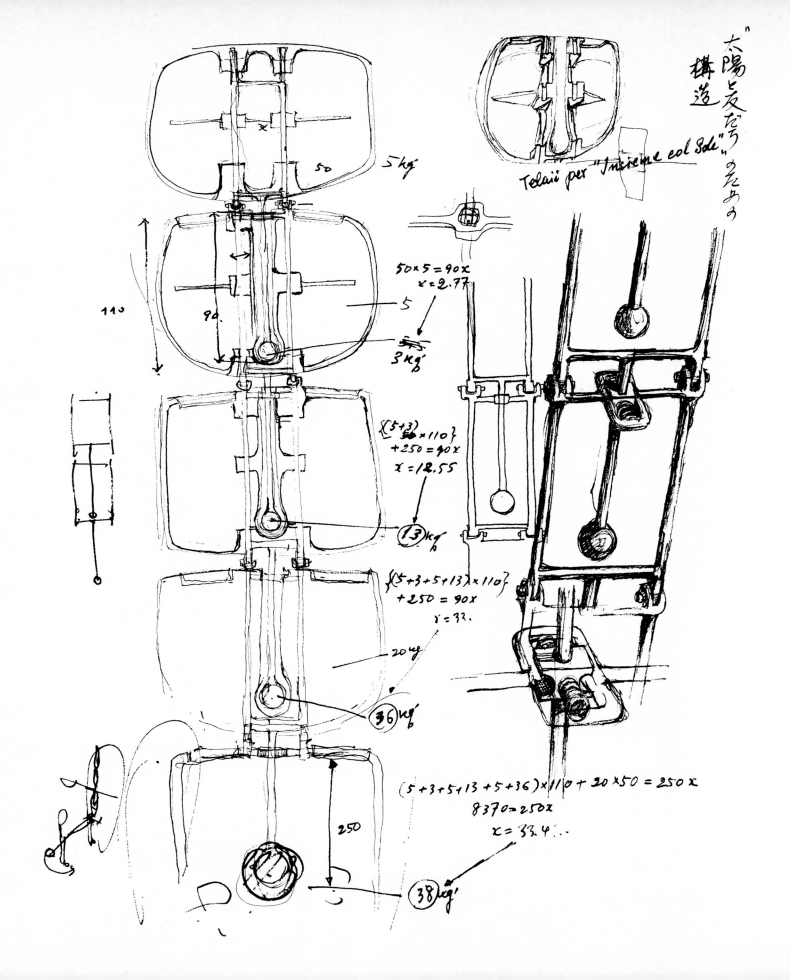

太陽と友だちのための構造

Telaii per "Insieme col Sole"

50 5 kg

$50 \times 5 = 90x$
$x = 2.77$

5

110 90

3 kg

$\{(5+3) \times 110\}$
$+ 250 = 90x$
$x = 12.55$

13 kg

$\{(5+3+5+13) \times 110\}$
$+ 250 = 90x$
$x = 33.$

20 kg

36 kg

250

$(5+3+5+13+5+36) \times 110 + 20 \times 50 = 250x$
$8370 = 250x$
$x = 33.4...$

38 kg

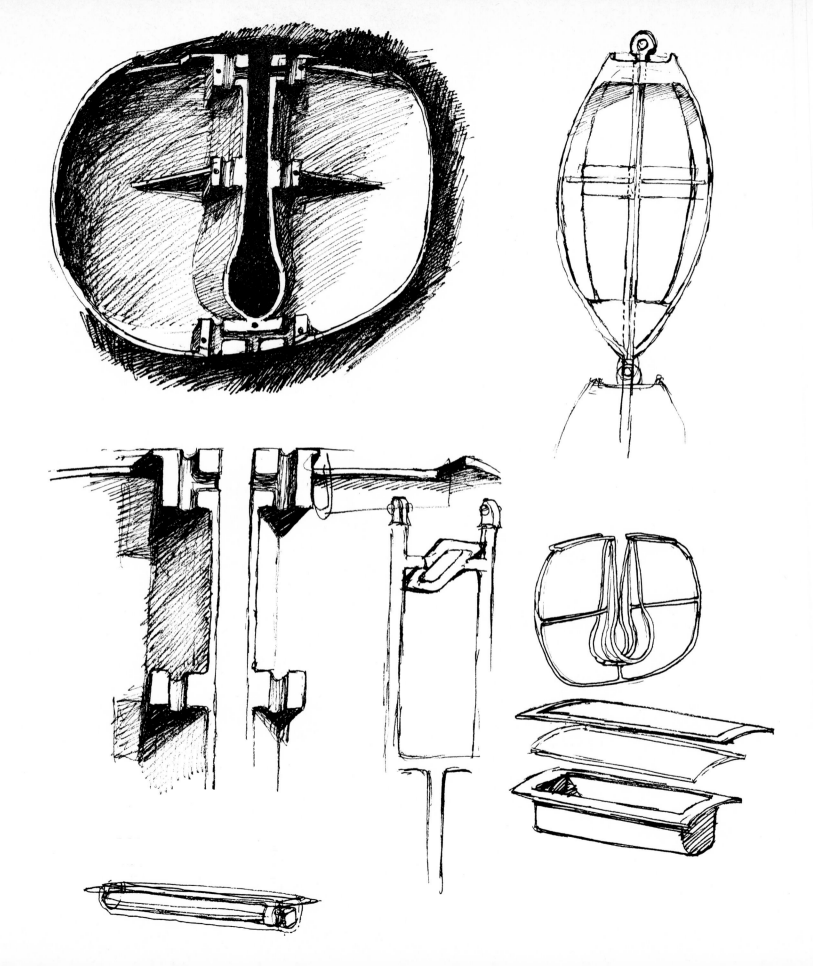

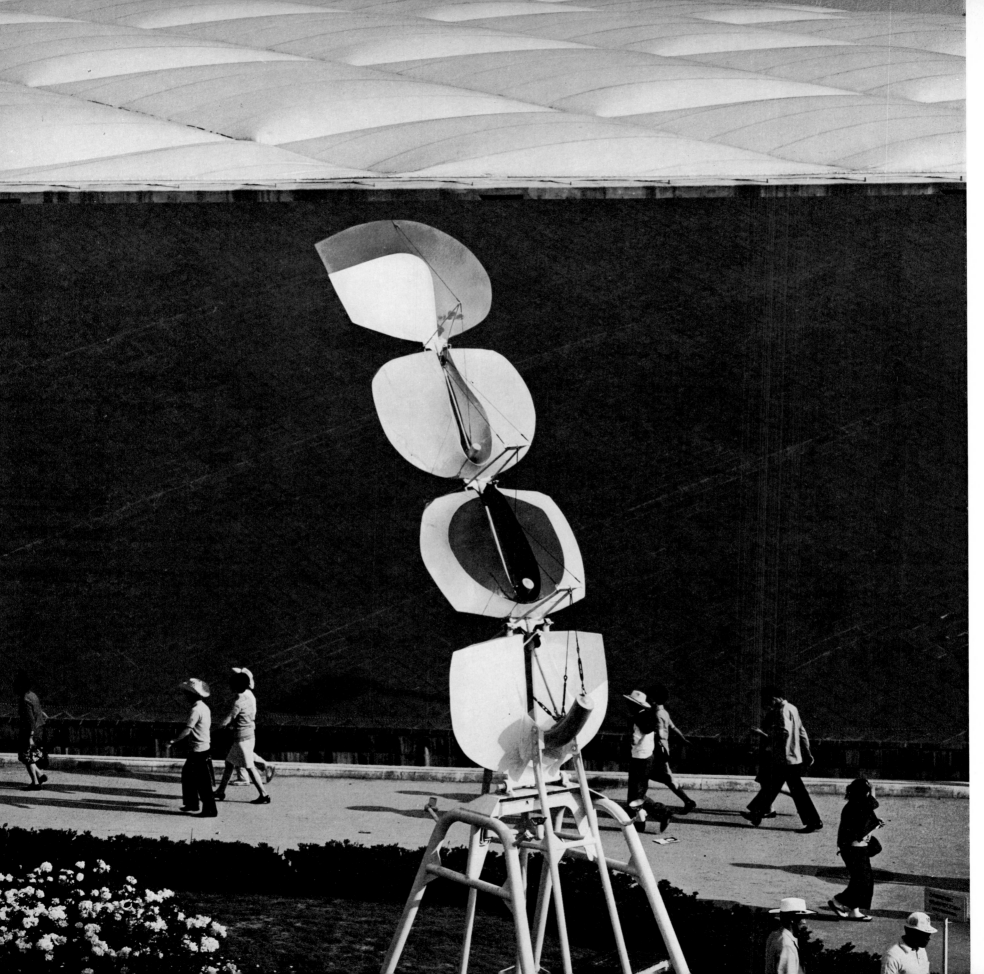

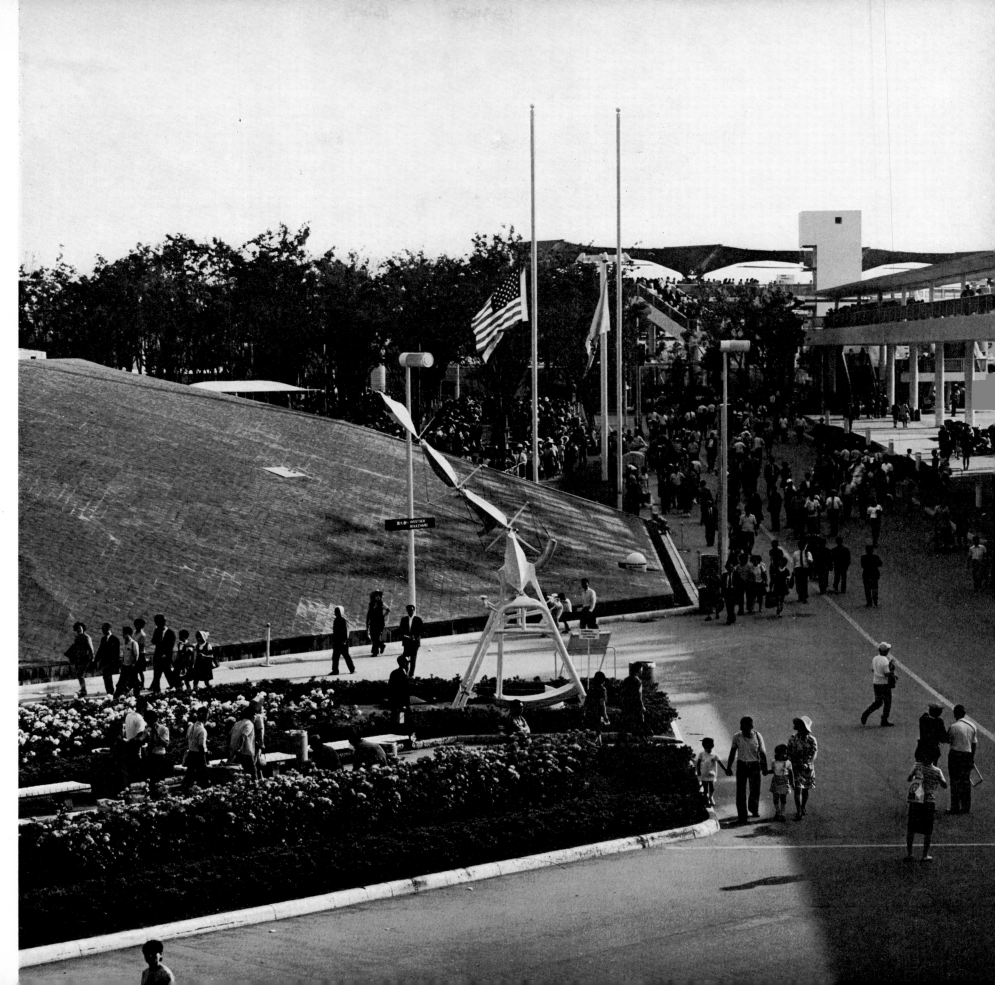

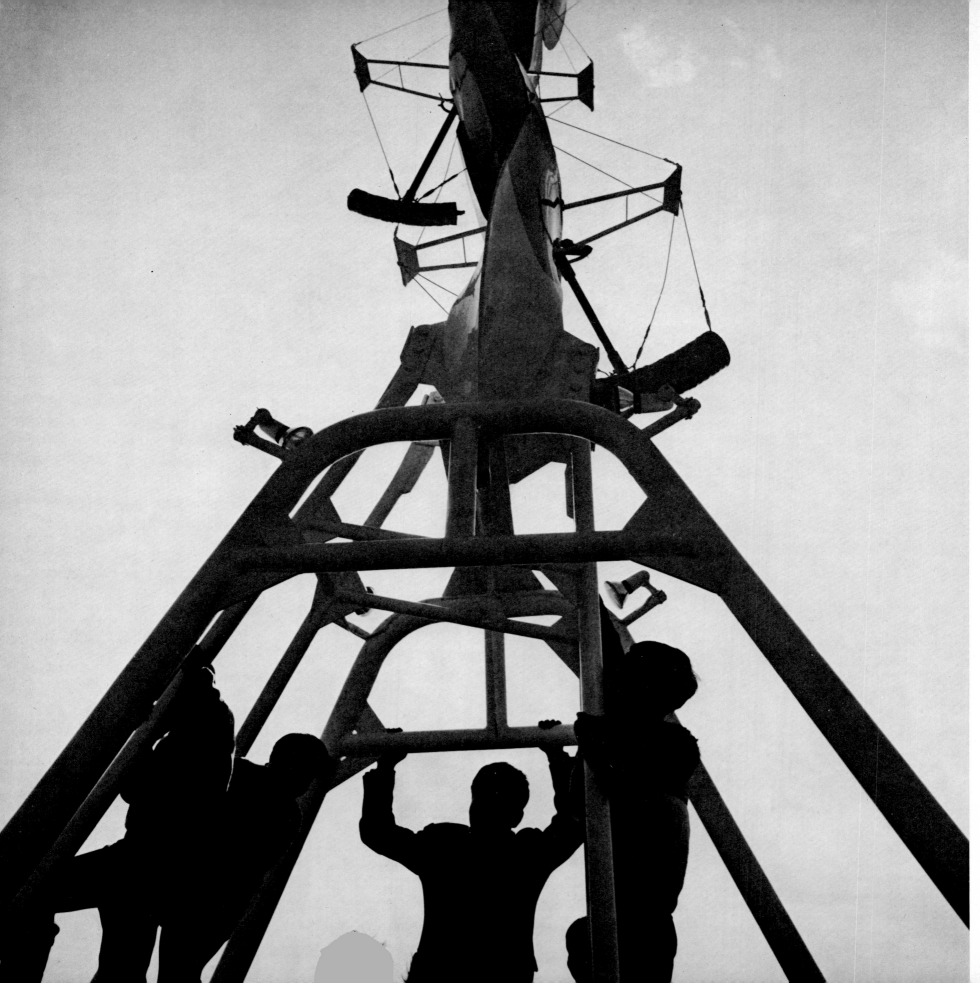

Dynamic and complex movement characterizes *Together with the Sun*, which, when viewed from below, gives the impression of a great mass jutting upward and outward into the sky. Even the gentlest breezes, however, are sufficient to set its parts in delicate motion. Four steel-pipe legs, set firmly in the ground, form the basic platform, above which are four slightly thickened, scoop-shaped plastic units that, as they move in the wind, evoke images of ships, sails, or kites. Flexible joints in the assembly make this movement possible, and four lead counterweights—decreasing in size and weight from the bottom of the structure upward—accelerate and vary the motion. The three upper counterweights, shaped like slightly curved T-form knobs, employ tactile appeal to generate a clean, crisp visual impression. The very large, lowest weight hangs in the space between the legs of the base platform, where it doubles as a swing. Although the top three units respond immediately to the slightest breeze, unless children are actually playing on the swing-counterweight it and its attached plastic unit move very slowly. A mechanism that permits flexible variation in motion and skillful distribution of volumes throughout the construction allows the individual units to react together while maintaining independence of action. Thus any force applied to the various parts is transformed into a highly complicated vision.

Movements in wide arcs endow the sculpture with a certain humor: when the scoop shapes bend into an S curve the top one almost touches the ground, and as this happens, the whole piece looks like a bowing human figure. But humor is not the only impression the work produces, for at times its powerful surging motions seem to draw the viewer skyward and to swell his heart with emotion. In addition, the untrammeled action of the simple forms as they pass freely in space refreshes the spirit. At night, four spotlights shining upward through the sculpture intensify the effect of complex movement and produce an impression of general trans-lucency.

Playing-Card Country.
Molded plastics and steel, height 65¼″
Ajinomoto Company, Tokyo
(exhibited in the Chemical Industrial Pavilion at EXPO '70)

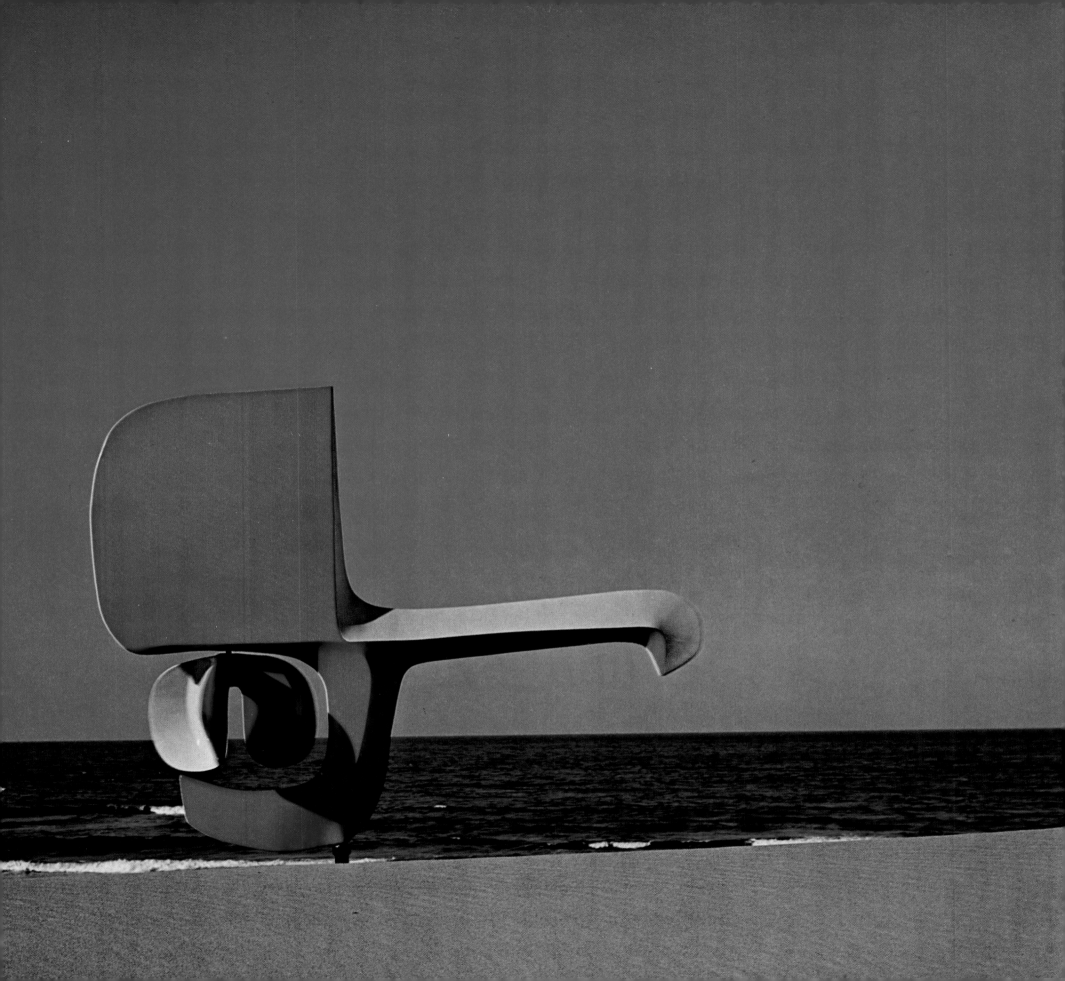

Communication of Plants. 1968
Molded plastics and steel, length 10′4″
Collection the Artist

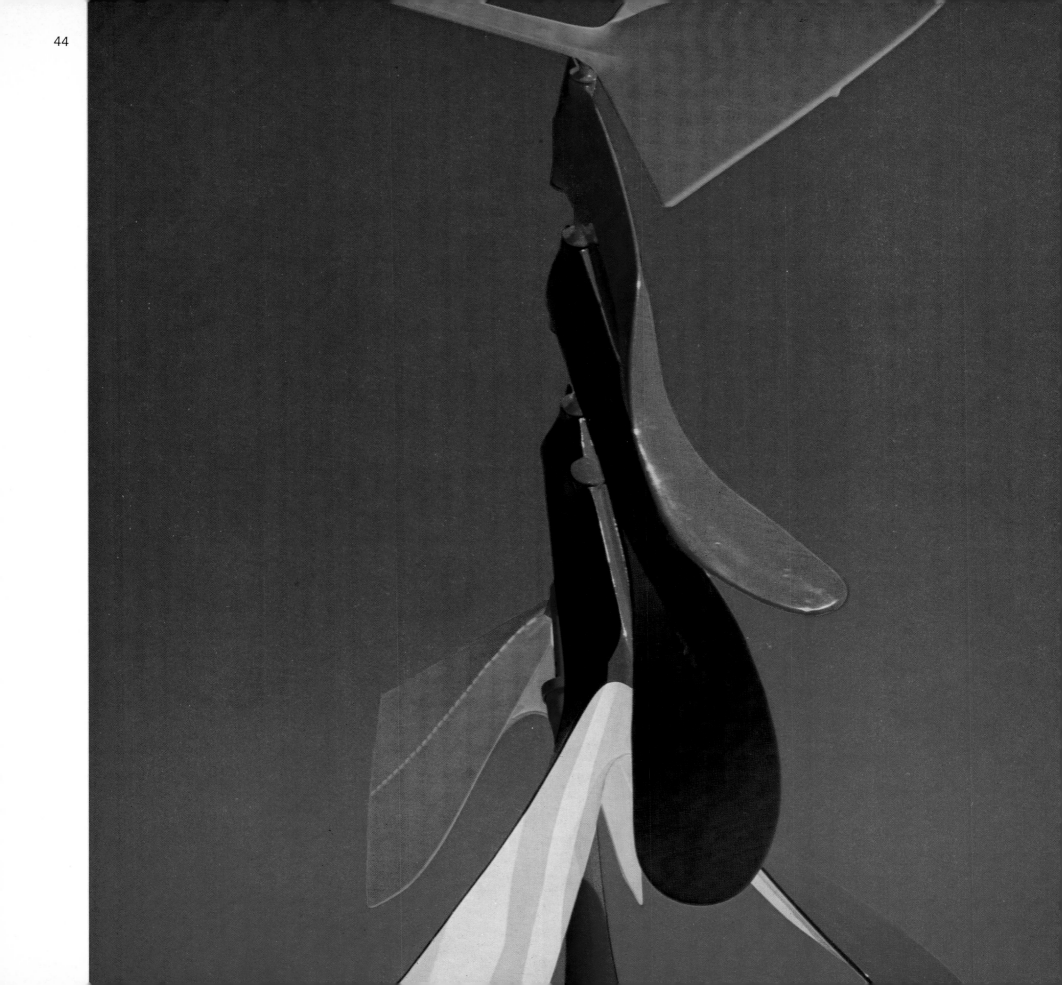

Its movement characterizes the sculpture. At a glance, the form seems simple, but the curves in the propeller shapes intercept the wind to put the composition into complicated and delicate motion.

A fixed basic axis supports the construction. Viewed from above, the five upper units are placed in a straight line. Although the large yellow tailpiece is rigidly fixed, all the other units move. A view from the side shows that these four moving units are placed at slightly different heights. The finial piece is shaped like a bud, but the other three moving units are all basically the same in form. Since they are curved in different ways, however, when they catch the wind they move in different fashions. The tailpiece keeps the entire construction headed into the wind, but the four front sections move in various directions. This is especially clear when the sculpture is viewed from the front. As one part swings left, another swings right, thus setting up a motion that, seen from the side, recalls the rushing in and rolling out of waves. The combination of changing directions in the whole structure and the upward-downward, right-left motions of the component parts evoke a multitude of impressions. Furthermore, the color scheme—yellow, vermilion, blue, green, and white—intensifies the varying movements, while the use of yellow in both the tail and bud sections unifies the whole.

When the swing of the four moving parts is violent, it describes a complicated swelling in space, and the sculpture becomes a whirling mixture of color. This phenomenon is similar to what happens in another work, *Distant Land* (p. 48), when the violent rotations of its moving parts create the illusion of a globular body: in both works the impression is of a visual volume which is much greater than the actual volume of the sculpture.

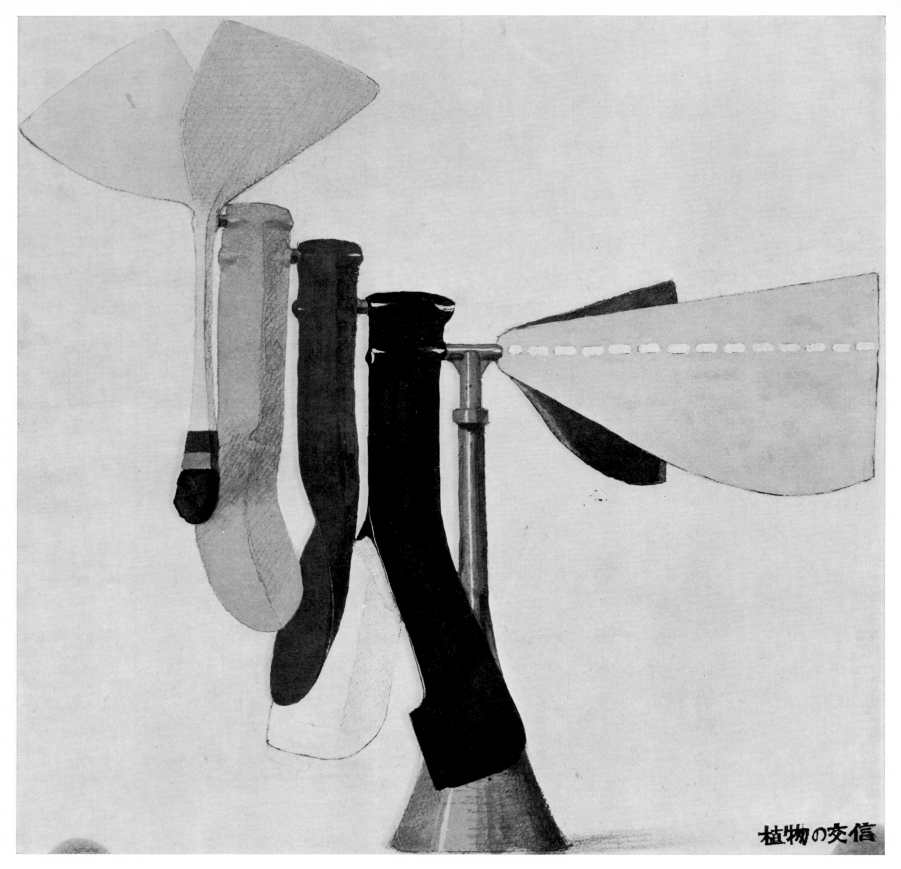

植物の交信

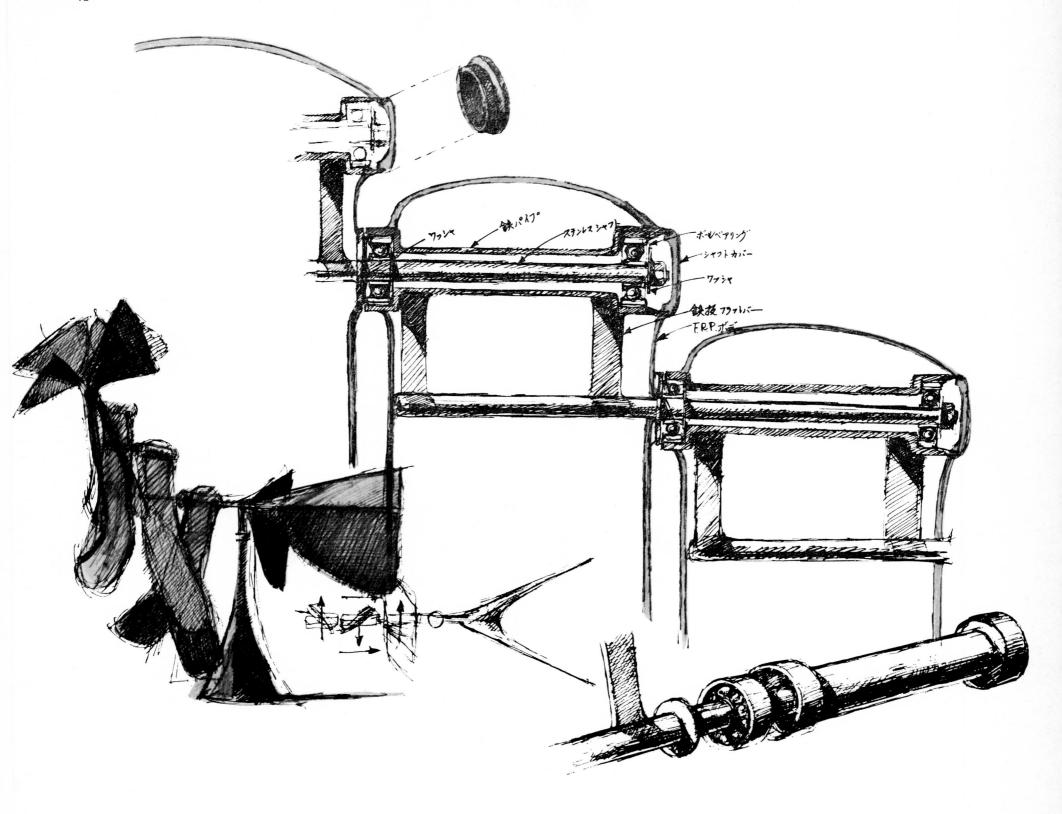

ワッシャ
鉄パイプ
ステンレスシャフト
ボールベアリング
シャフトカバー
ワッシャ
鉄板フラットバー
F.R.P.ボディ

Water Beam. 1969
Stainless steel, height 8′ 3 1/4″
Toyo Hotel, Osaka

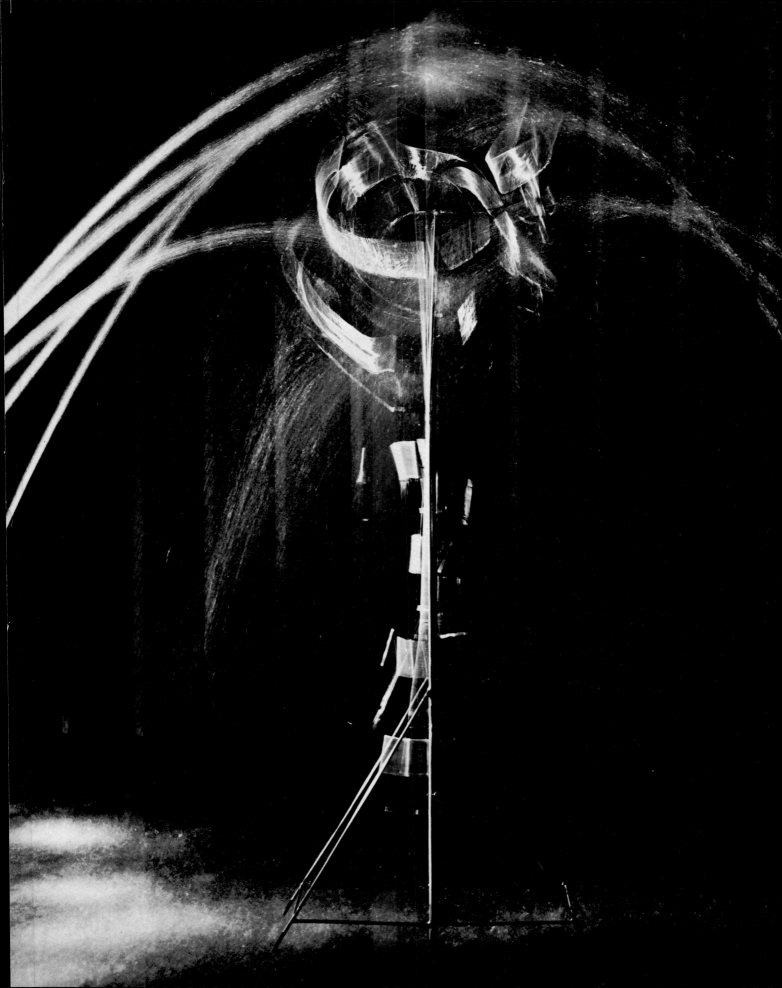

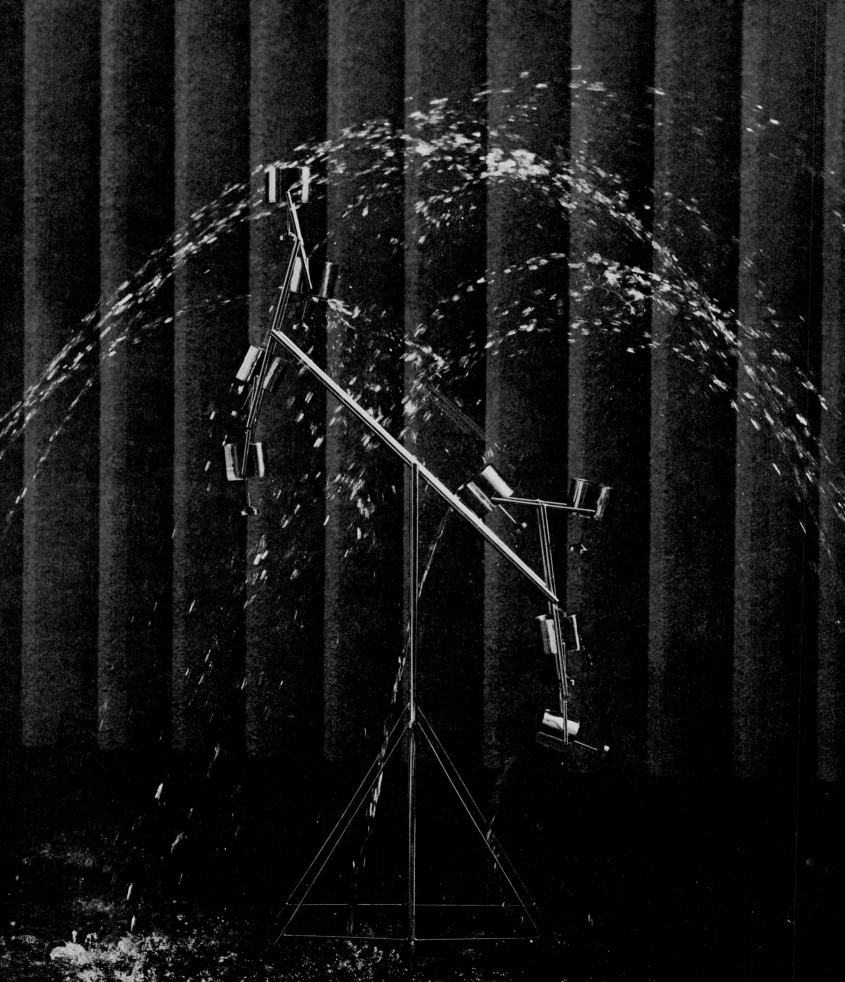

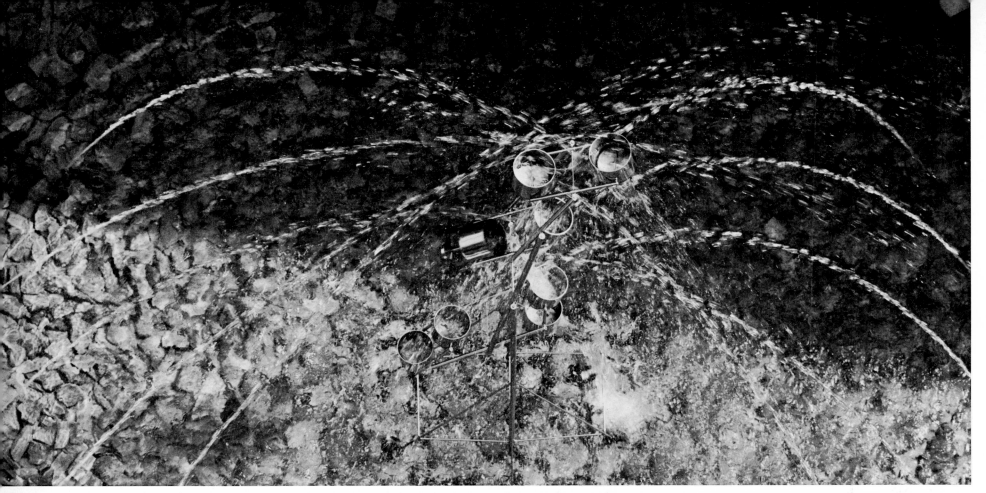

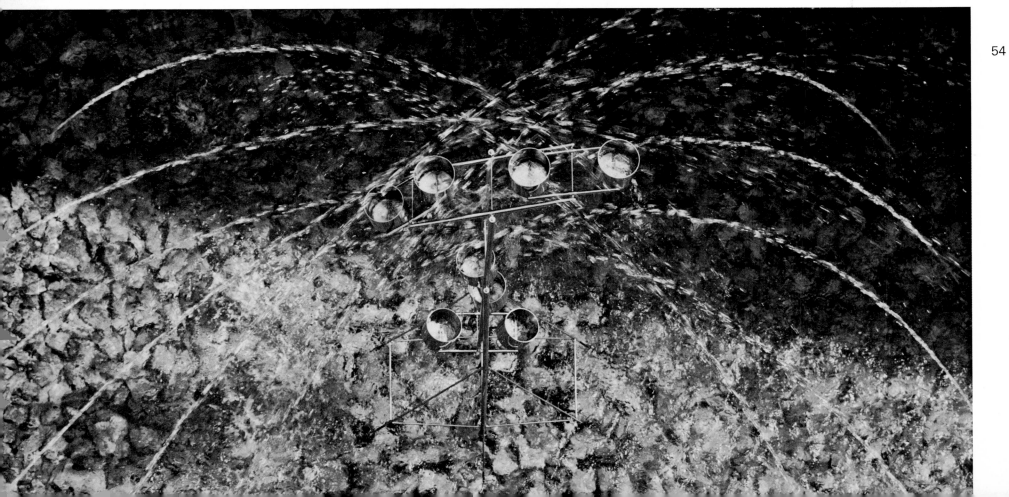

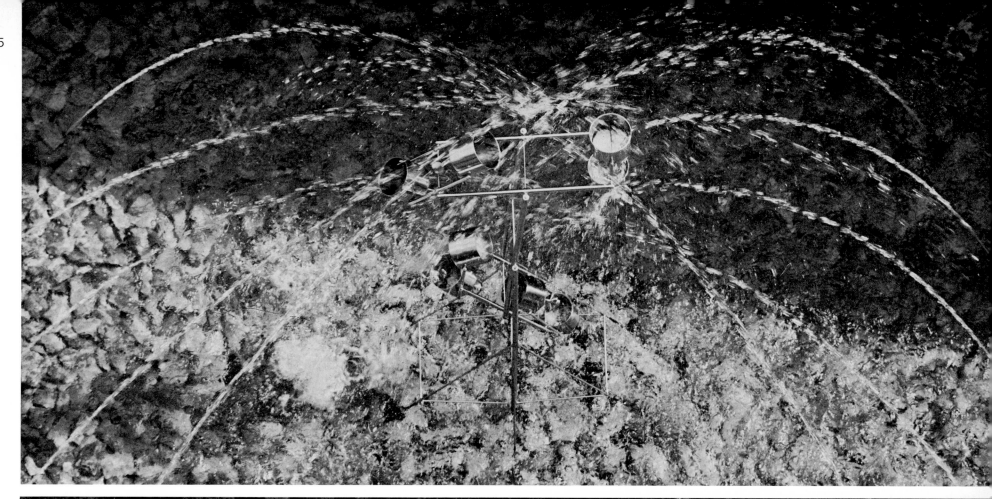

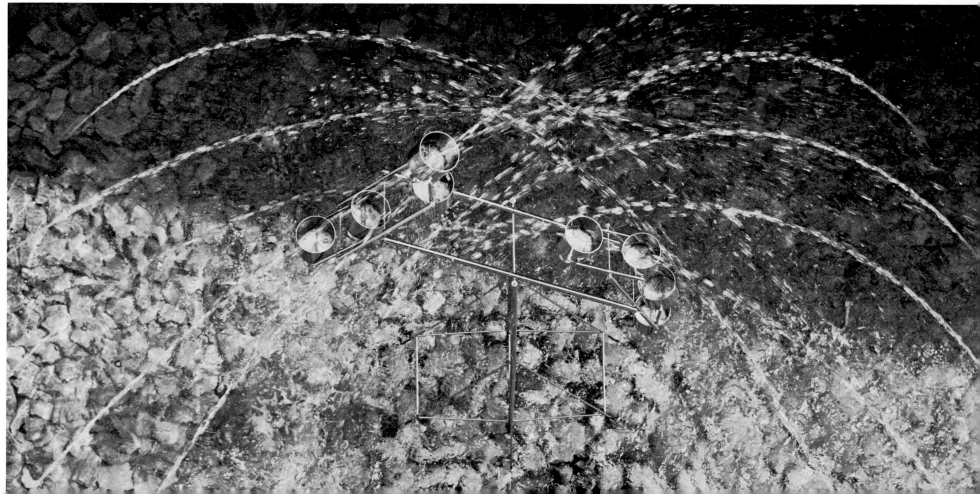

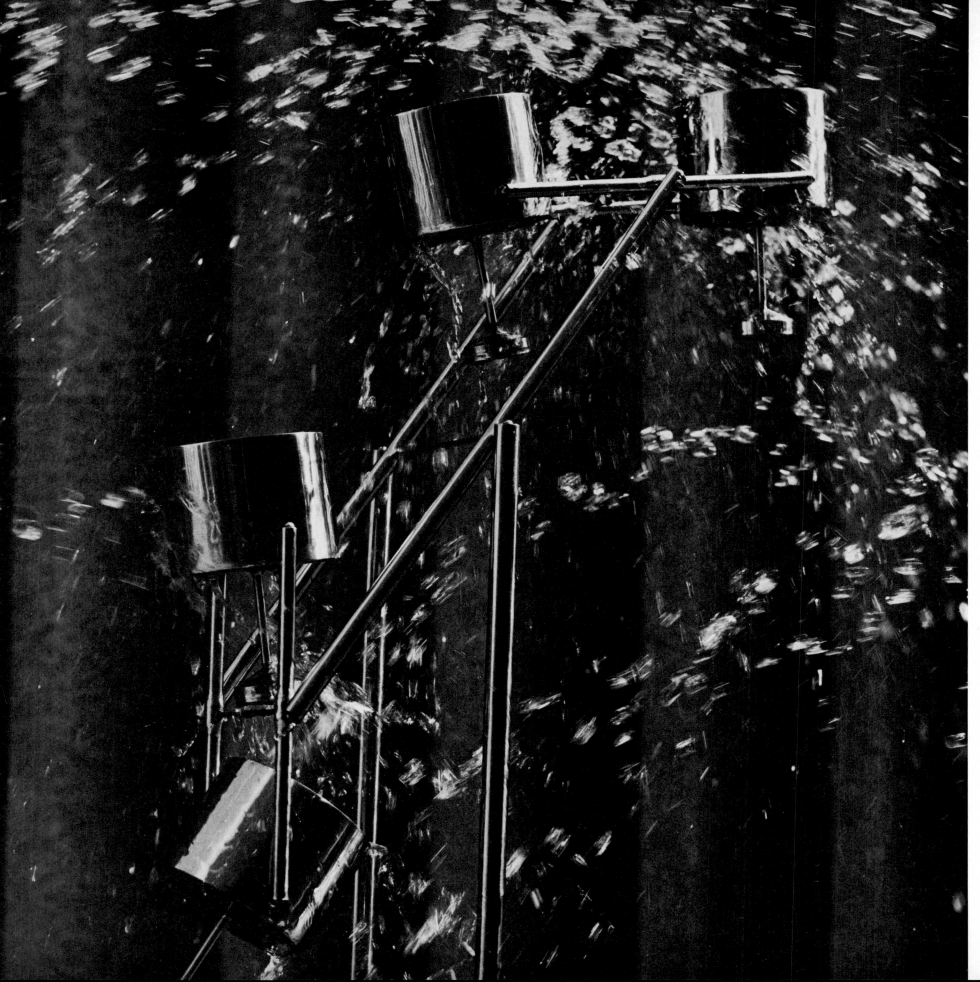

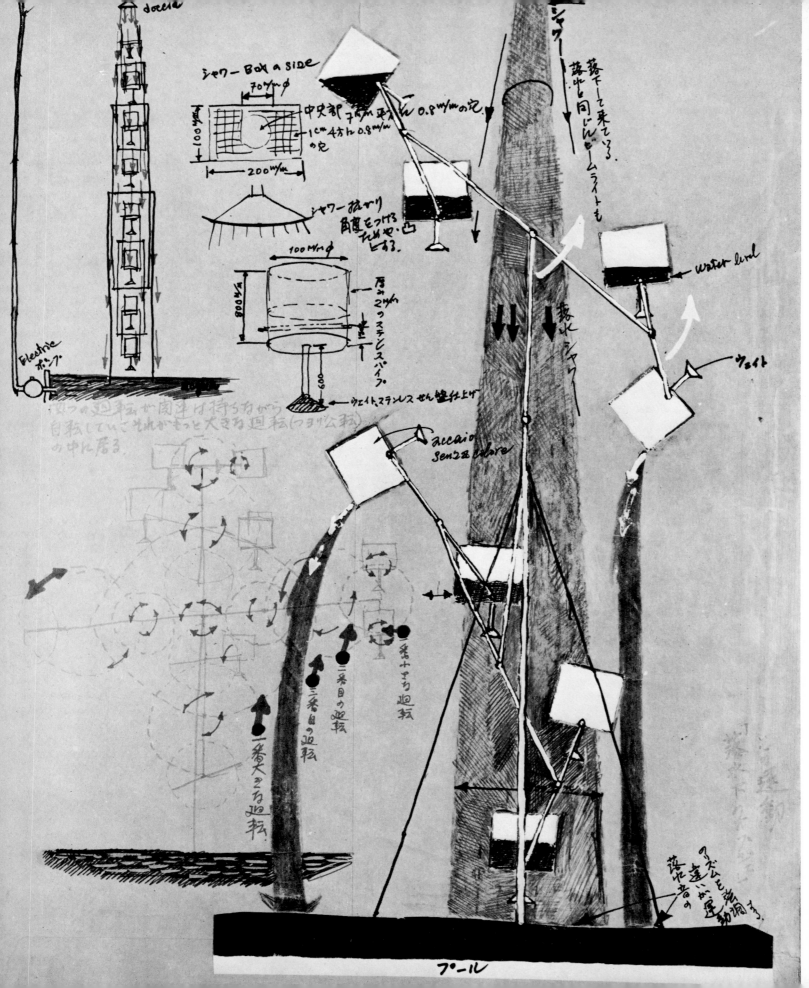

The use of unpainted stainless steel is unusual in Shingu's work. Since the coldly gleaming, polished metal surfaces reflect and project light, the physical nature of the material seems to vanish and only the framework of the sculpture floats before the viewer's eyes. This framework consists of eight cups attached to movable axes—four cups in the upper and four in the lower section of the composition. Water falling from above fills the cups and sets them into complicated and ceaselessly altering motion. The basic structural unit is a set of two cups in a seesaw arrangement, and the central principle of motion involves an imbalance between the weights of the two cups. In simple terms, the idea is this: as one cup fills with water and thus becomes heavier than its partner, it falls and sends the empty one upward. (Basically the principle resembles that used in a Japanese garden-pond ornament consisting of a length of bamboo pipe attached to a stand in such a way that it swings free in a wide arc. Water flowing from a flume fills the upper section of the bamboo to the point at which it must fall forward, thus sending the empty, lighter end upward. As the water spills from the full end, it returns to its original position. When this happens, the lighter end swings downward and strikes a stone set below it, producing a pleasant hollow clapping sound.) In *Water Beam*, two parts consisting of two joined cups each swing in the direction of the cups containing the greater amount of water. Both the upper part of the sculpture—two sets of two cups each—and the lower section—another two sets of two cups each—move in accordance with the same basic principle.

Although the development and action of one set of two cups are largely independent, they are related to the motions of the other set of cups attached to the same axis. This relationship determines the incline of each larger group of four cups. The conception is similar to the principle by which the moon rotates around the earth, while the earth, revolving itself, rotates in its own orbit around the sun. Although the motion limitations of each part of the composition are fixed, since the centers of all eight parts are in constant movement, they establish varying relations among themselves. Furthermore, within these relationships they develop surprising motions.

While the general idea of the piece is simple—fill the cups with varying amounts of water, and the lighter ones will rise—this principle provides dynamic overall action. But one must not overlook the difficulties the artist faced in designing the unseen parts, the insides of the cups and pipes, to ensure the smooth motion of the whole, even though the demonstration of physical principles which this work represents appears to eliminate the personal nuance of its creator.

Locus of the Right Angles (model). 1970
Projected size 65′7″ × 98′5″

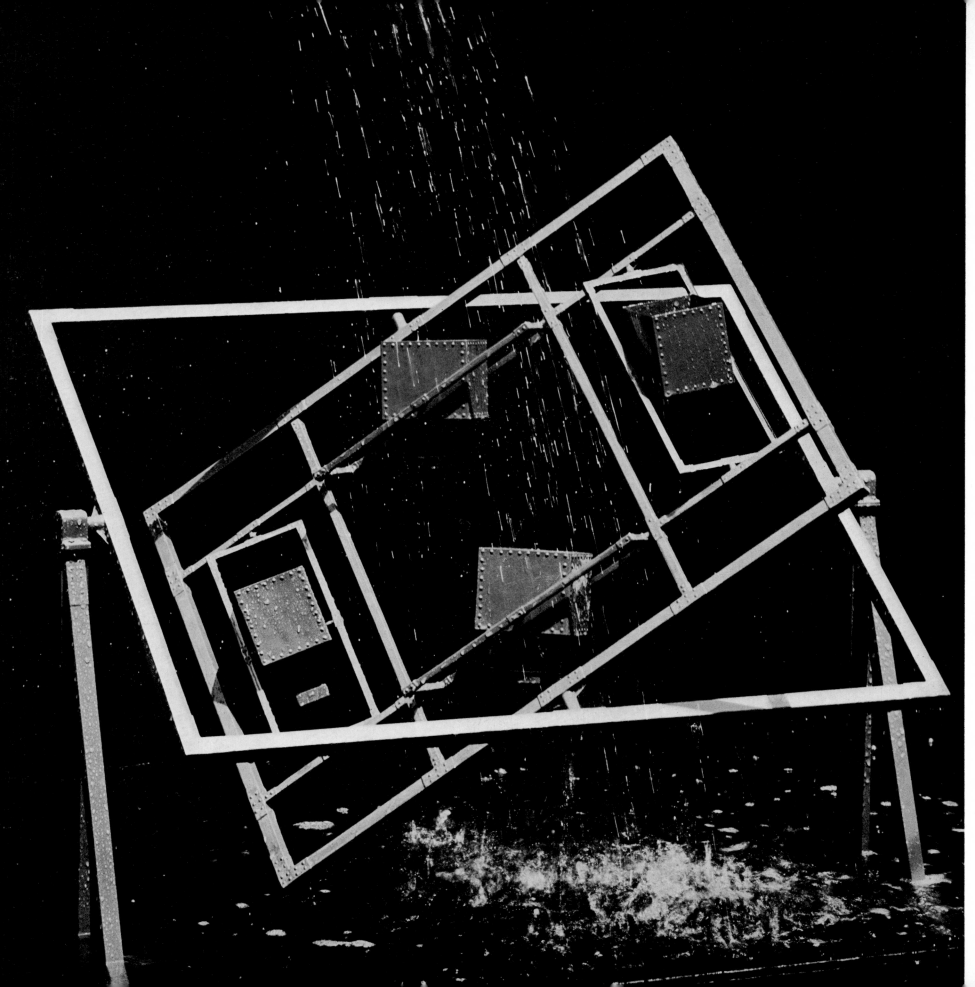

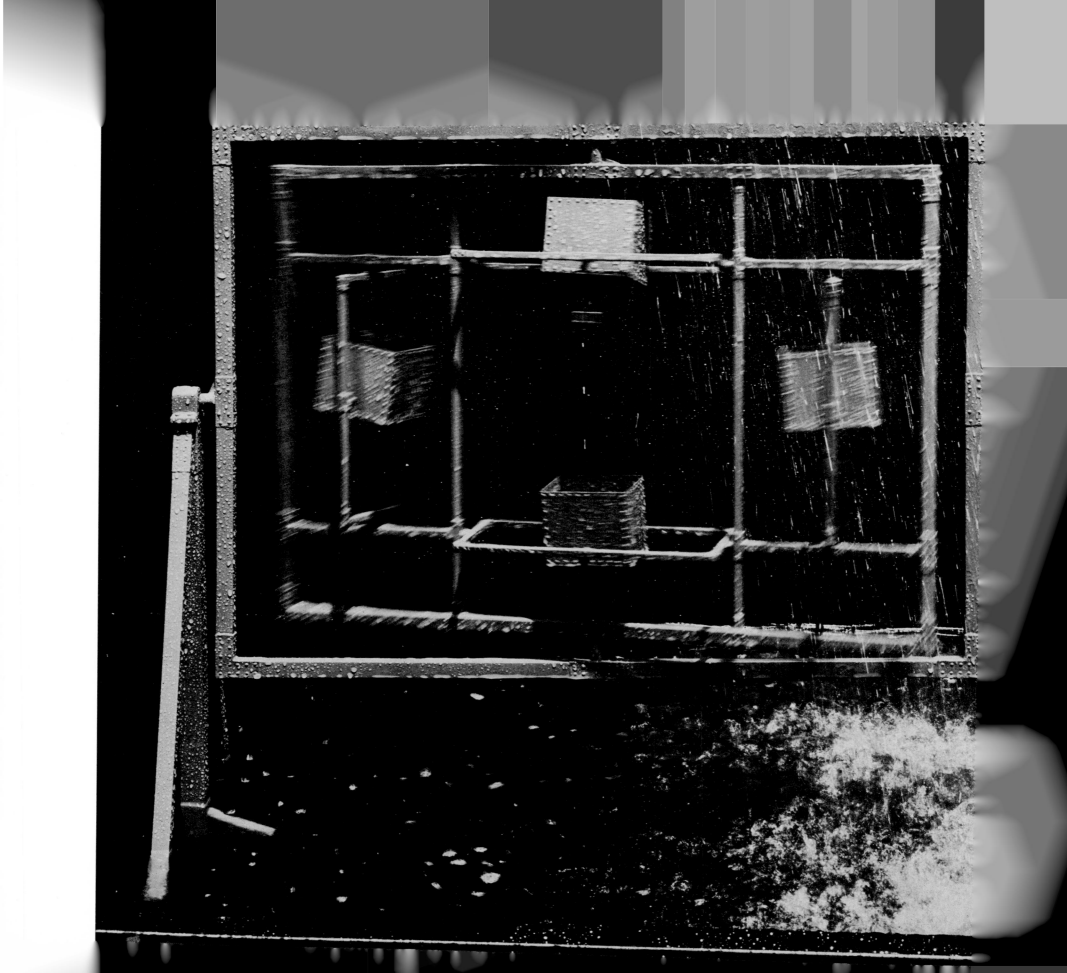

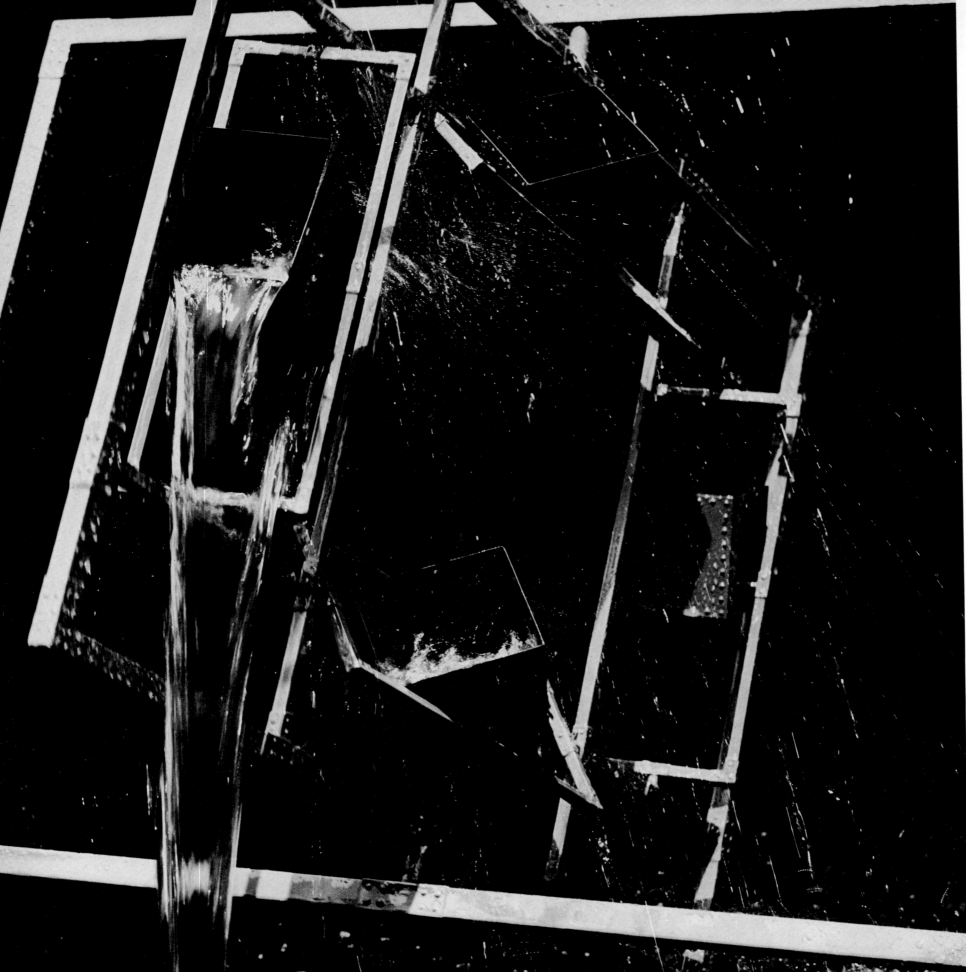

Following the general principles applied in *Water Beam*, this construction uses gyrostabilizers in the axis to permit soft flexible motions in right-angled parallelepipeds activated by water falling from above and filling them. When one looks at the sculpture from the front, its movement seems to bear down on one almost as if a mill wheel had run berserk. Since the movements develop upward, downward, right, and left, it is difficult to take all of them in at once. This, however, intensifies the appeal of the work. The motion is as varied and changing as that of a radar antenna; for that reason it cannot be limited to any one straight line of development. *Water Beam*, too, moves in a complicated way, but its construction makes the complexity apparent largely in side views. That is, *Water Beam* is fundamentally linear; its effect resolves into the purely visual. *Locus of the Right Angles*, on the other hand, develops both horizontal and vertical motion; consequently, it is simultaneously multi-dimensional and tactile.

The framework used to produce the movement in this work is basically identical with that employed in *Water Beam* and thus offers a good opportunity to pursue changes in the artist's ideas about forms. It seems that, instead of an impression of fixed images, Shingu here seeks images that expand like a landscape. At any rate, the world represented by the *Locus of the Right Angles* model deserves to be realized on a large scale—approximately twenty-two yards in height—although the artist's intentions would probably be intelligible if the work were about six and a half feet tall. Large size is desirable because, in order to grasp the motions of the work adequately, the viewer should see it from many angles; not merely from front, back, or side, but from below as well.

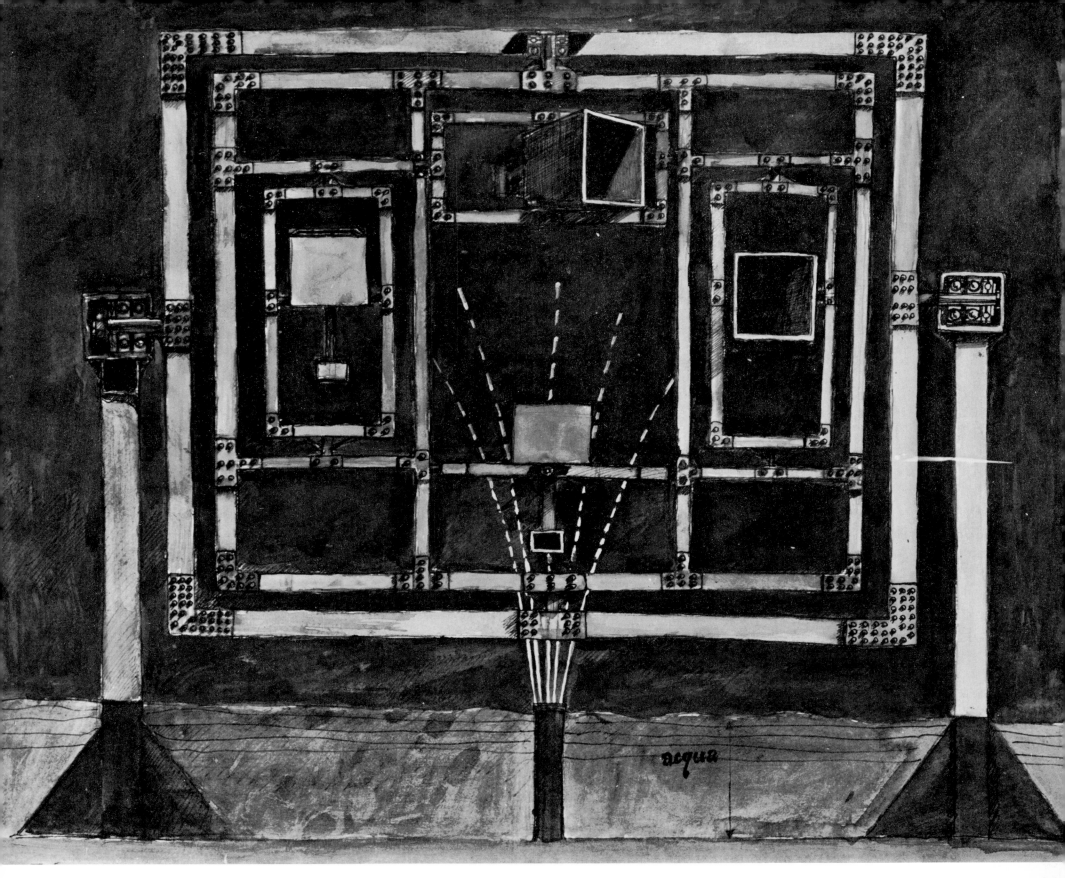

acqua

67

Bow. 1968
Molded plastics and lead, height 18$^{1}/_{8}$″
(one of a series of forty)

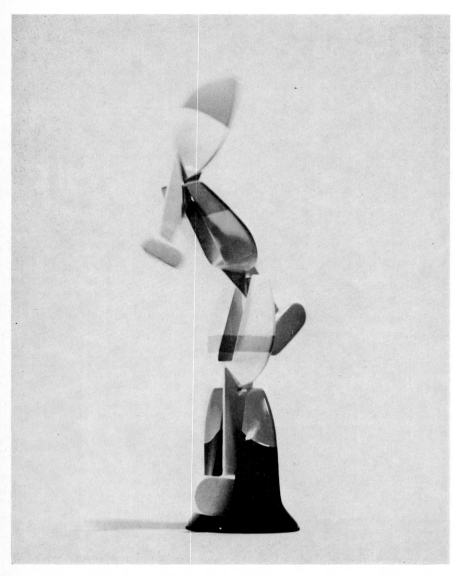

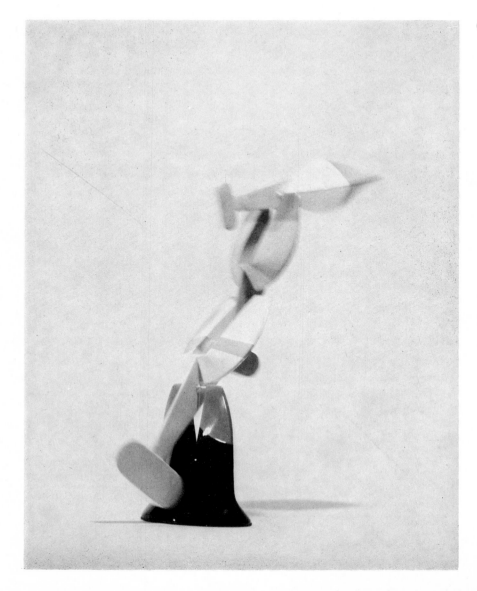

70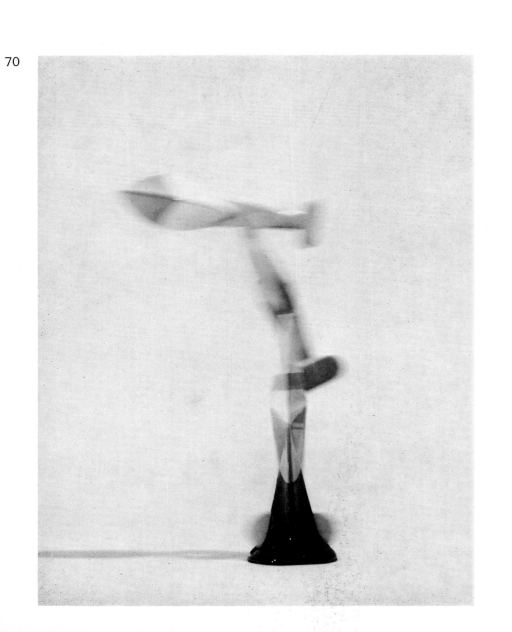

71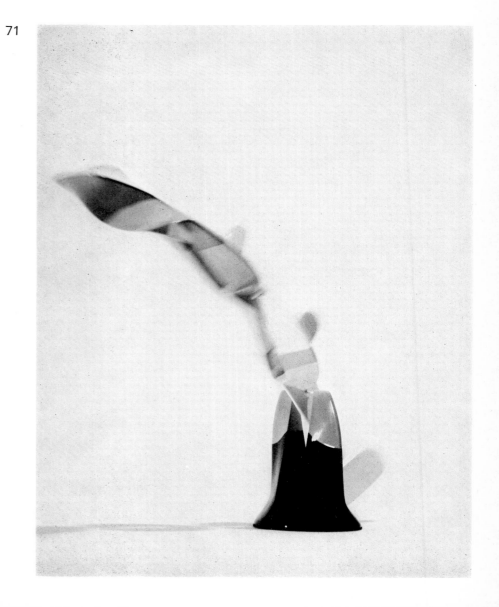

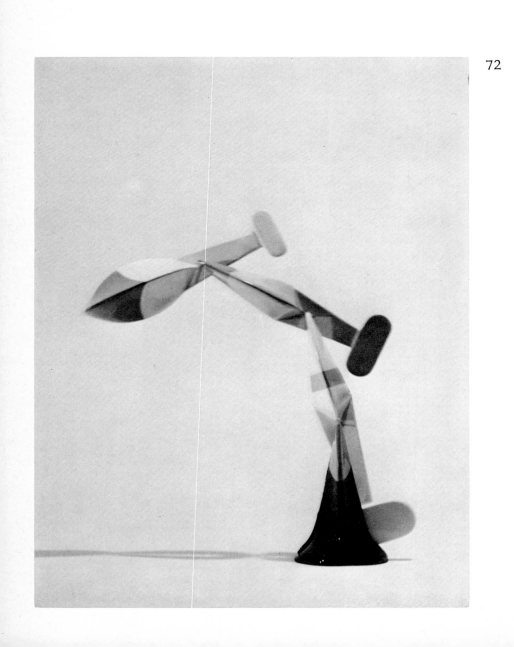

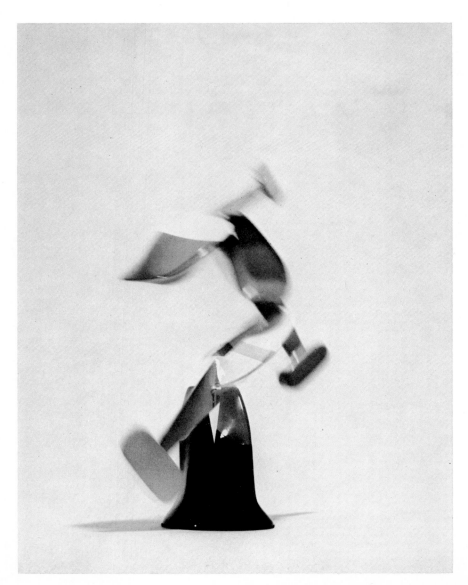

74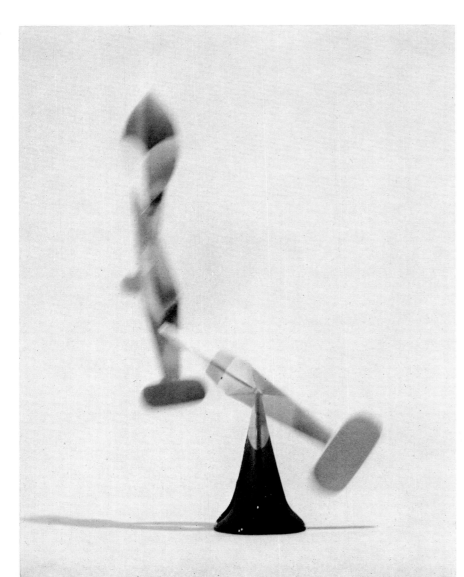

75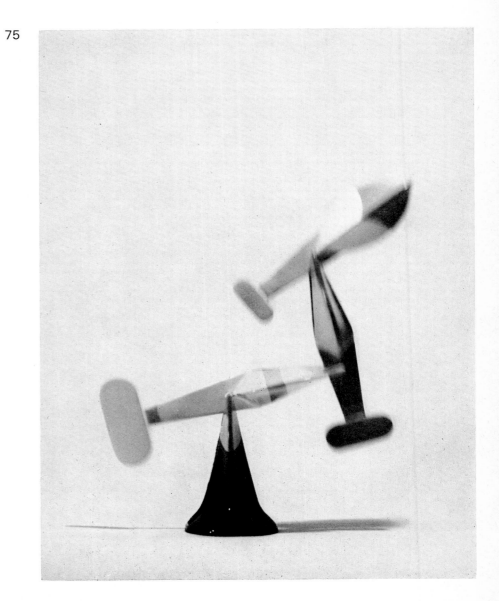

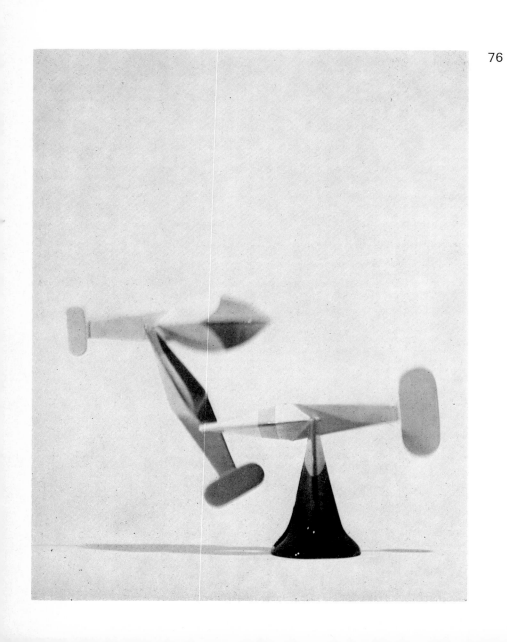

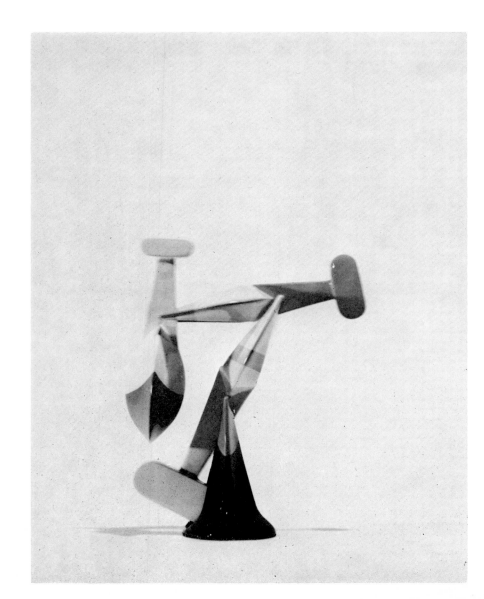

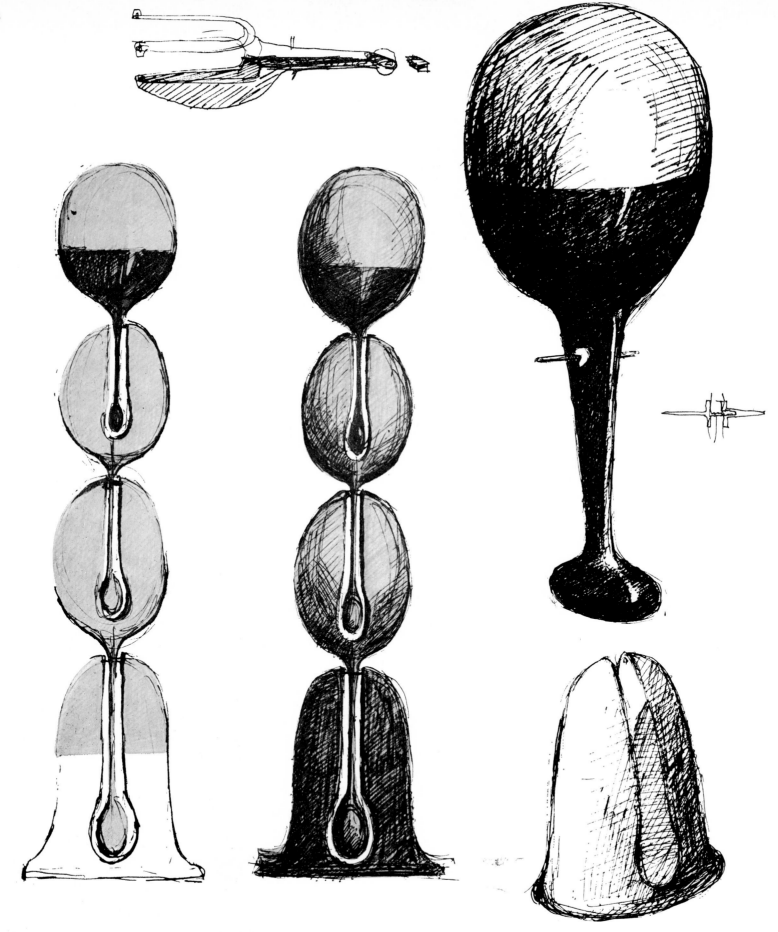

Memory of Adventure. 1969
Sailcloth, aluminum, and steel
height 16′1″
Collection the Artist

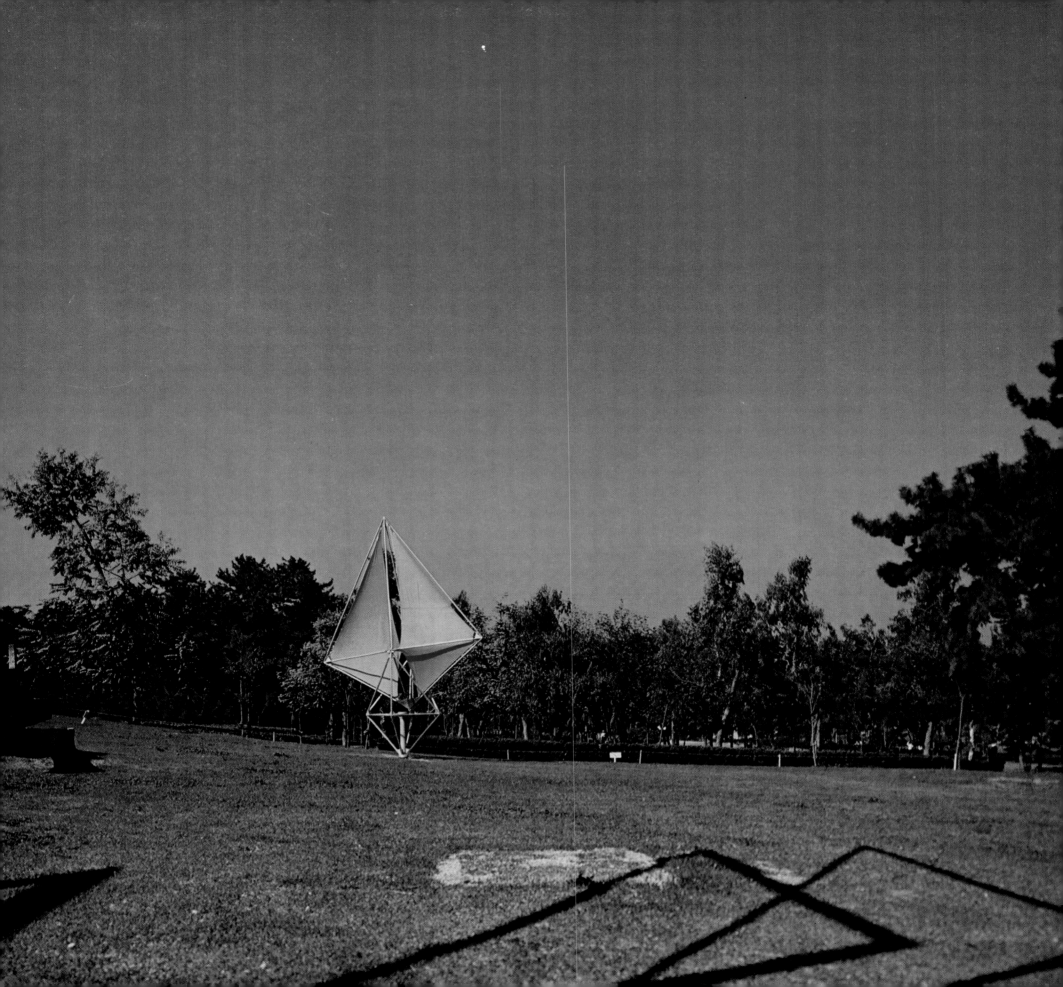

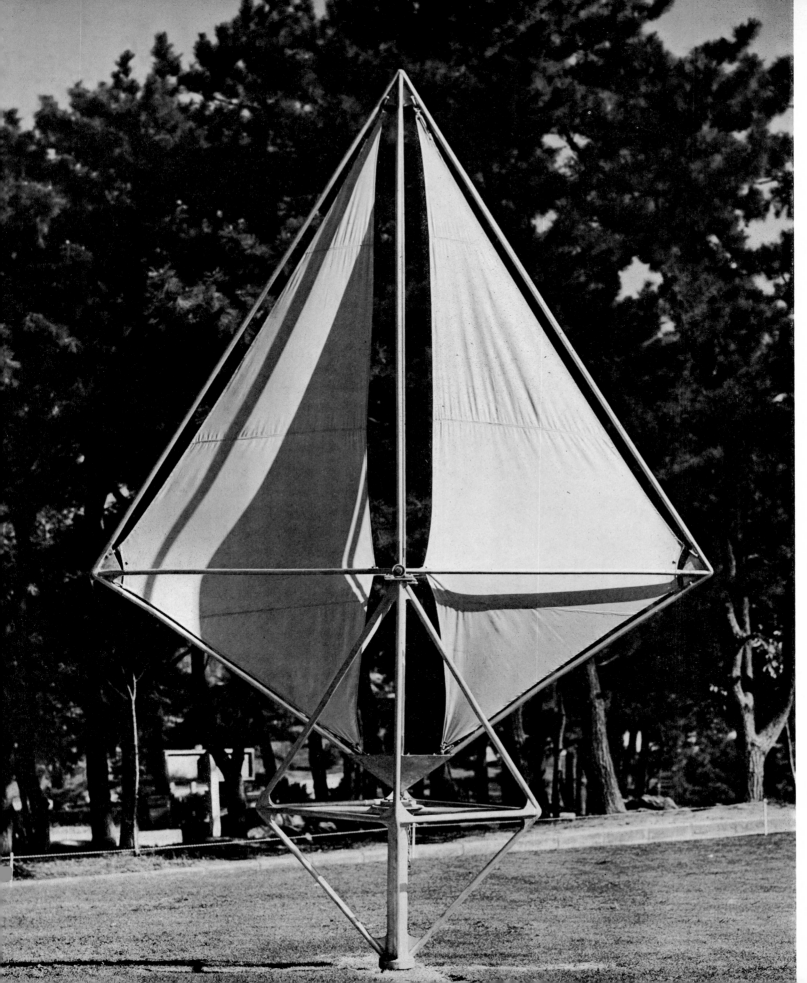

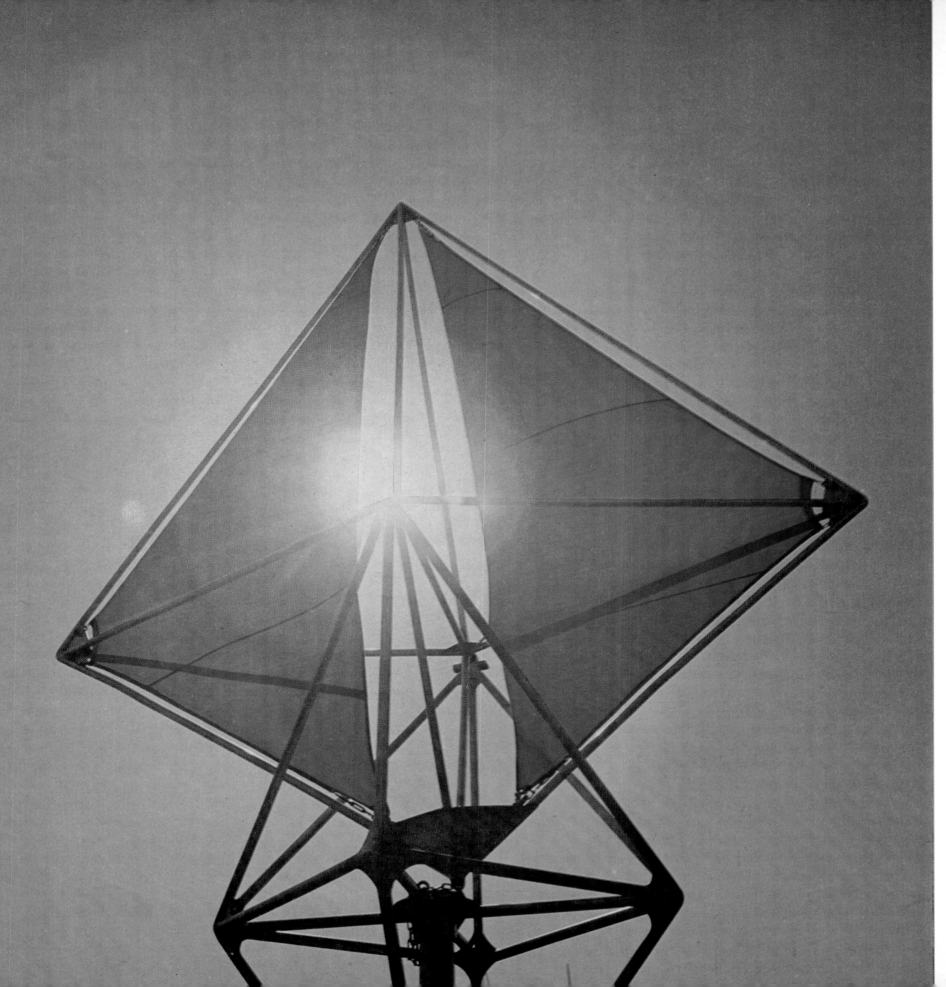

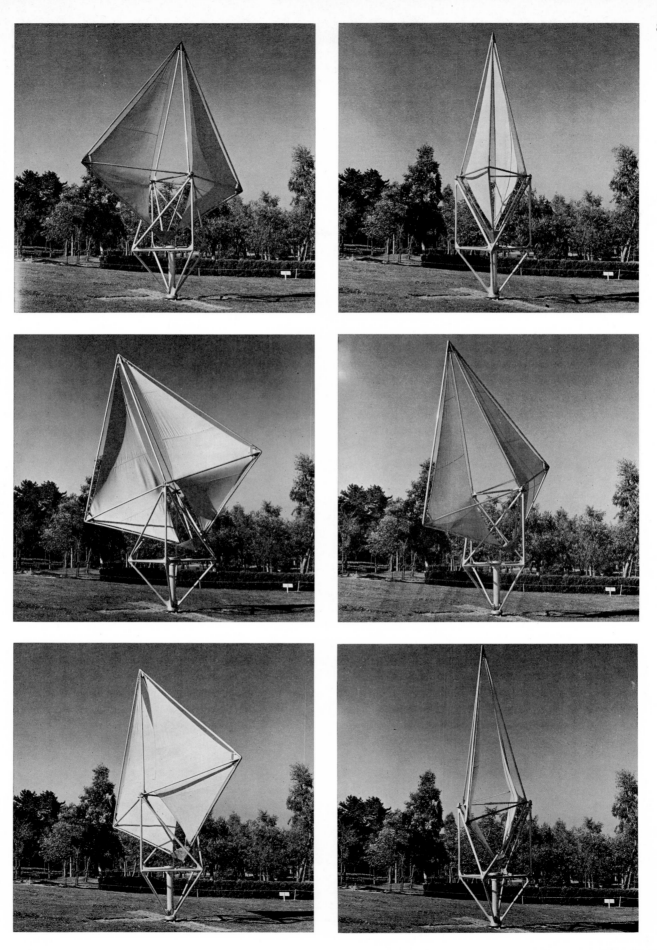

Two sheets of flaglike canvas straining in the wind and attached to a stout framework suggest a ship ploughing forward under full sail. This image in turn evokes associations with wave-beaten sea voyages. True to the keynote sounded by the title, the work is a yacht built on dry land to commemorate adventure—not a specific act or deed, but universal adventure in the wide world of nature.

Combinations of triangular units made of aluminum pipe cut a sharp spatial figure. Within the framework, which rests on a base that is firmly fixed in the ground, are stretched two nearly triangular sails. The point of juncture between the two major triangular units is the axis of rotation of the upper section. The slightly slack canvas sheets catch wind from both front and back, and as they do so, they bulge inward, or suddenly snap outward, depending on the direction of the wind current. This motion produces sounds that strengthen the impression of powerful motion. Although in comparison with some of Shingu's more curvilinear, round-surfaced works the exposed aluminum pipe construction seems stiff and rough, it is both bold and clear against the sky. It represents an objectification within space of the artist's ideas. One can trace the development of this tendency in Shingu's work from its initial appearance in *Together with the Sun* through its later manifestations in *Water Beam, Locus of the Right Angles,* and *Path of the Wind*. This line of thought results in a kind of space structure defined by the moving forms.

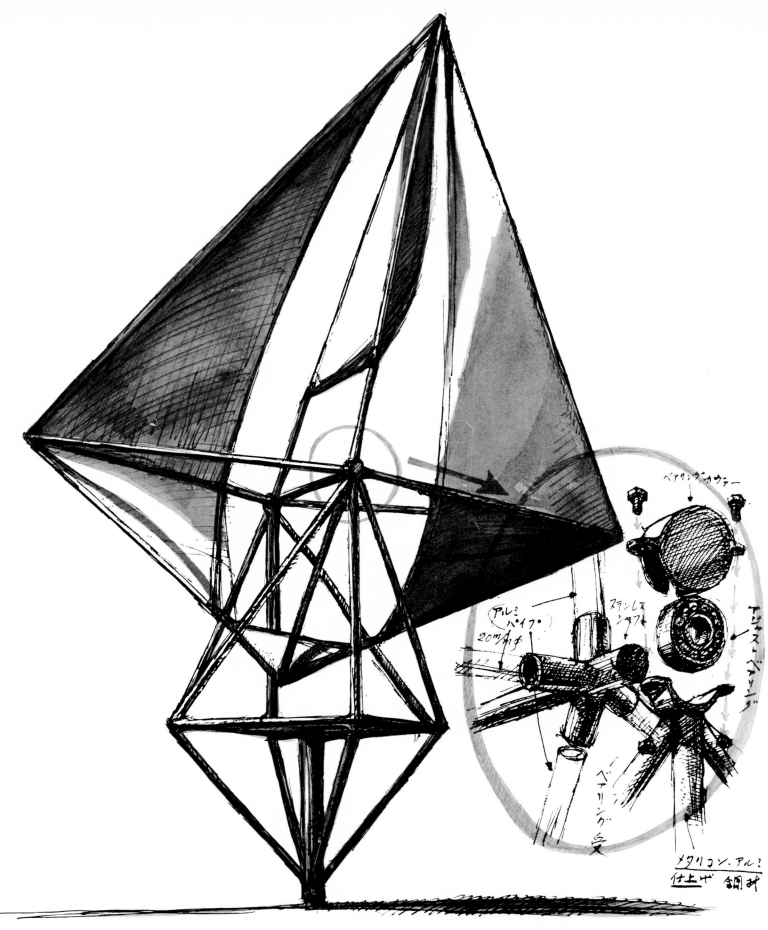

Poem of the Forest. 1967 ▶
Wood, molded plastics, and steel
4′4³/₈″ × 12′6″
Collection the Artist

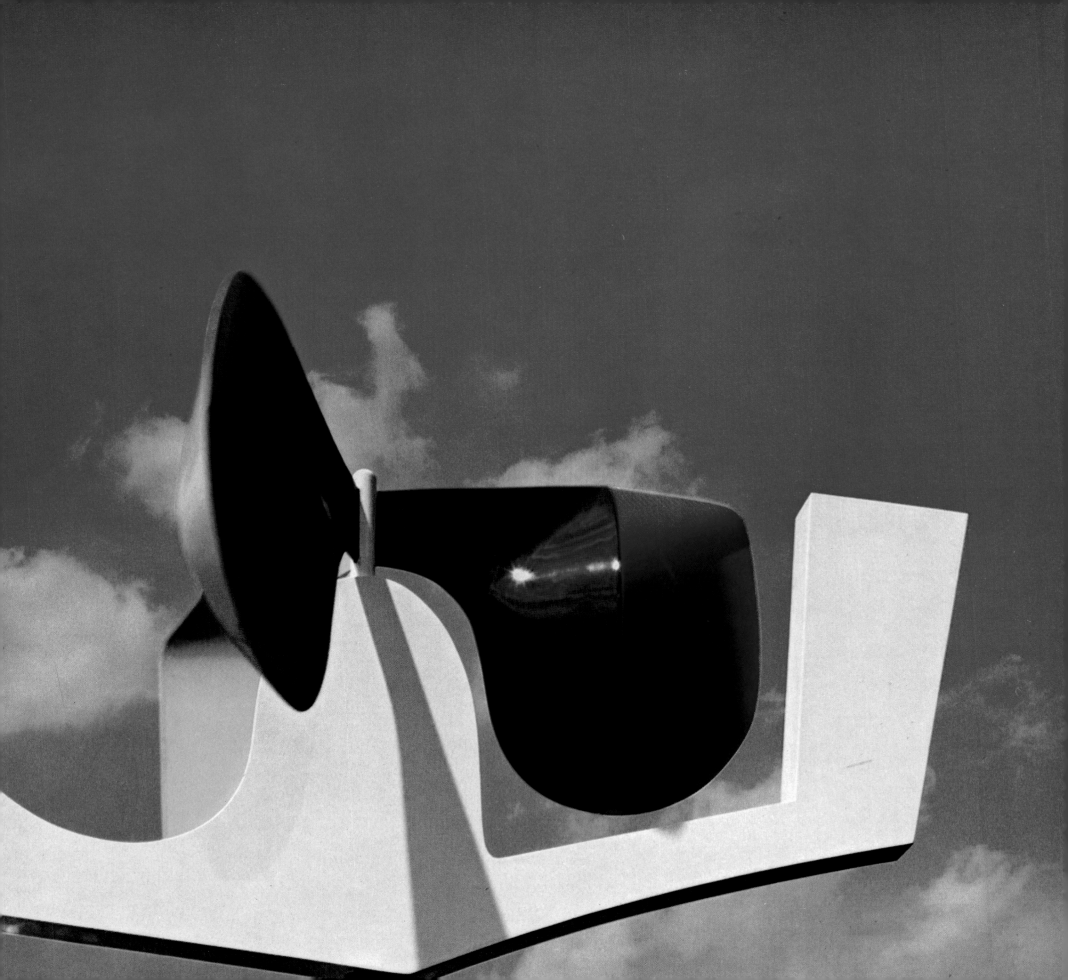

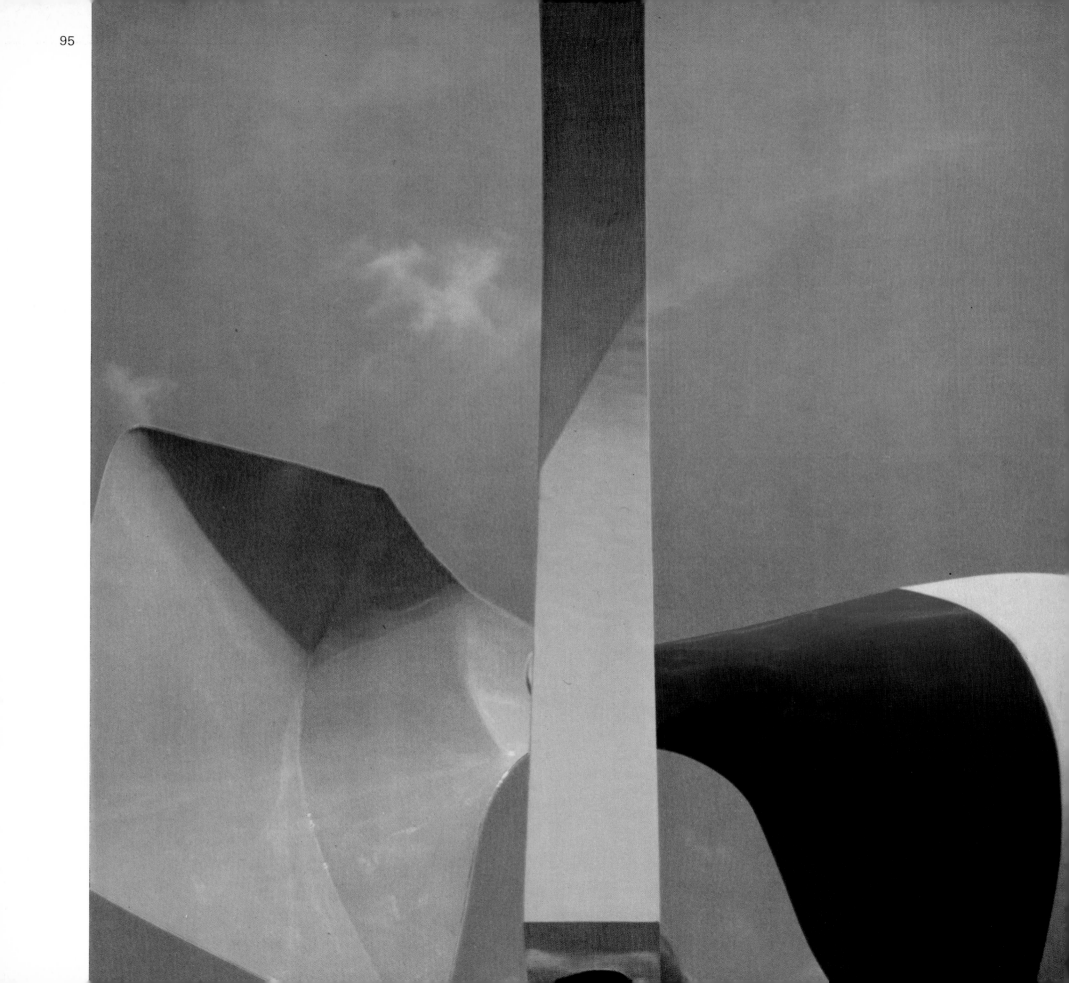

Path of the Wind. 1970
Molded plastics, steel, and stainless steel
height 65′ 7 1/2″
Senri-kita Park, Osaka

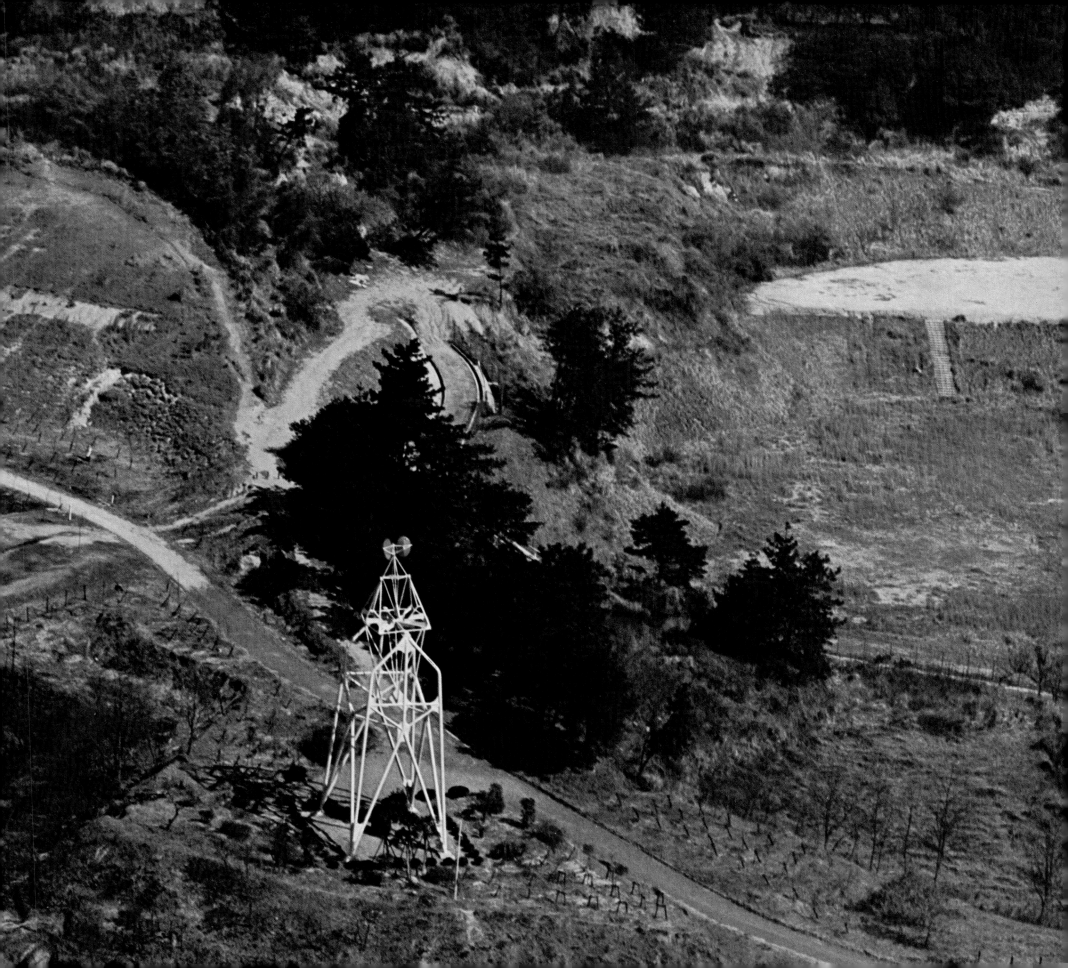

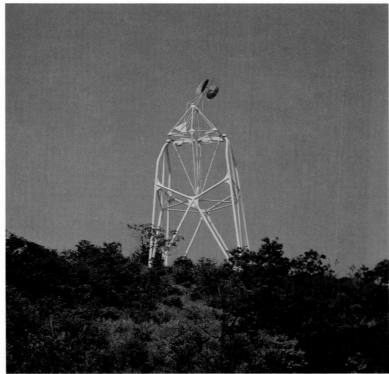

Distant Drum. 1967
Molded plastics, wood, and steel
height 7′4 1/2″
Collection the Artist

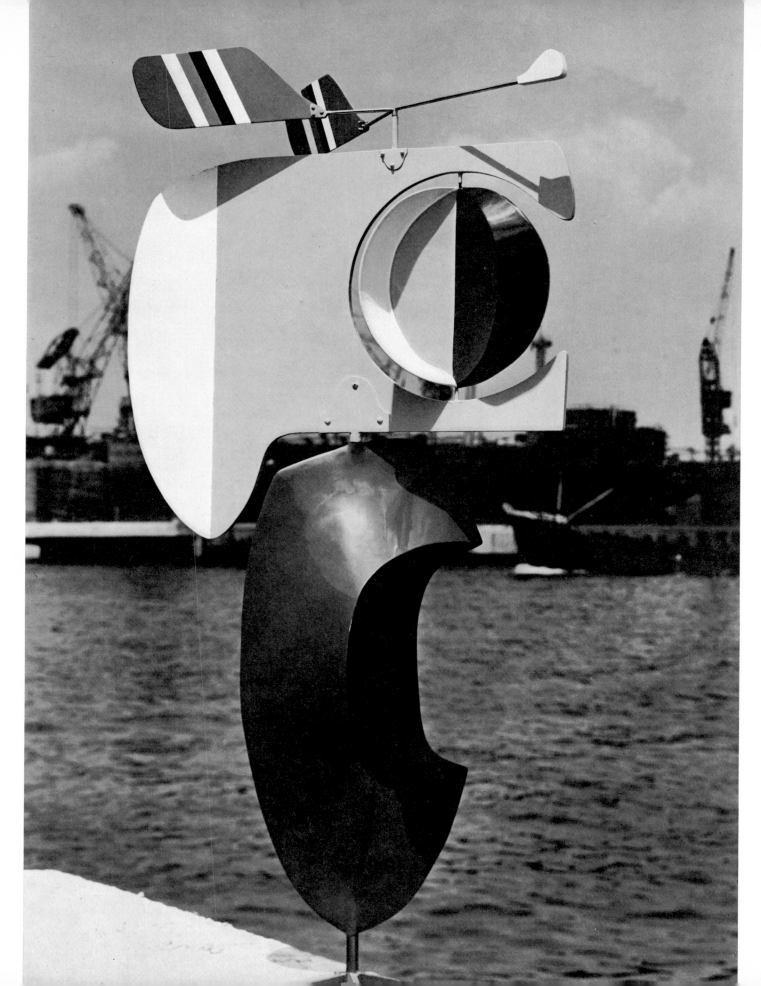

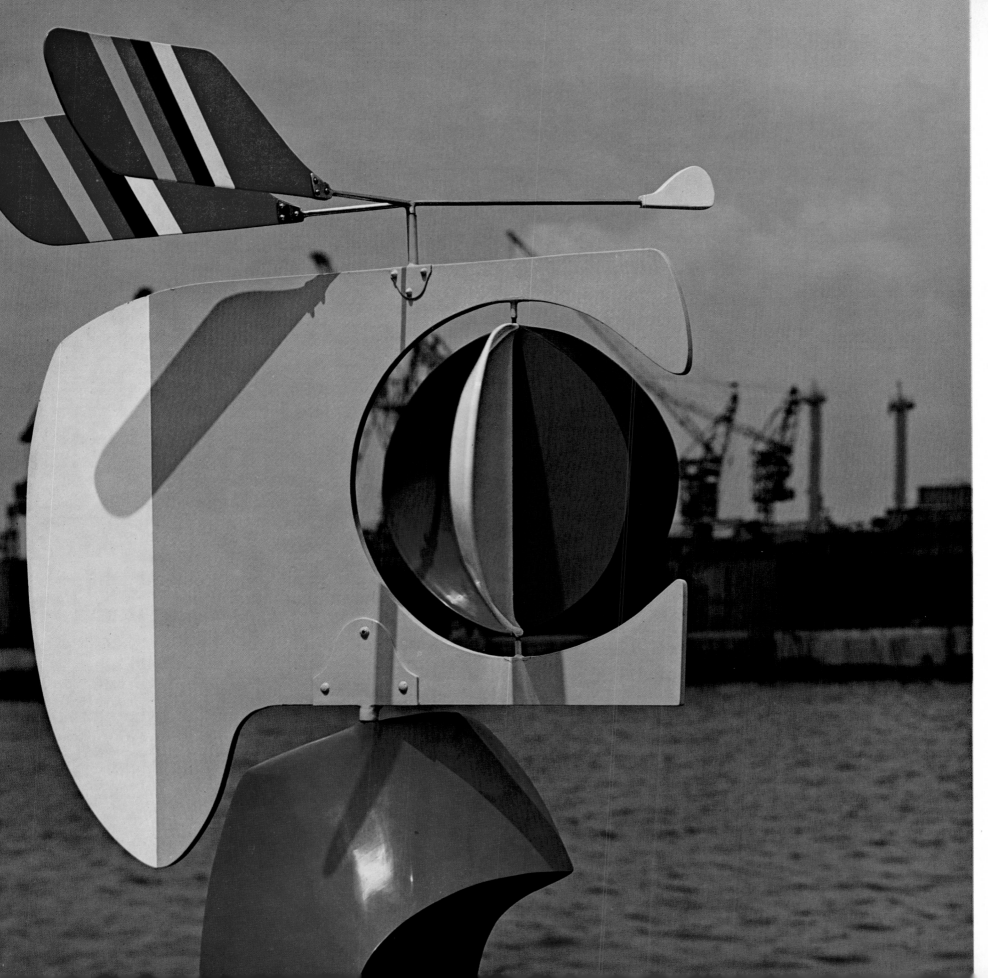

Box of the Wind. 1967
Wood and steel, height 7 $^7/_8$″
(three of a series of seven)

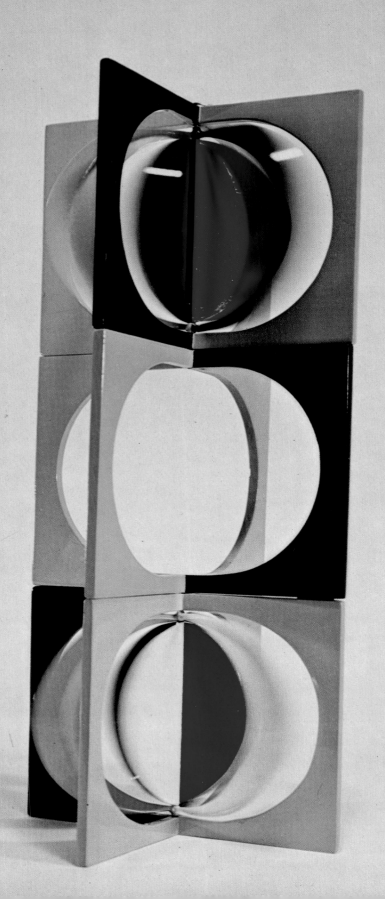

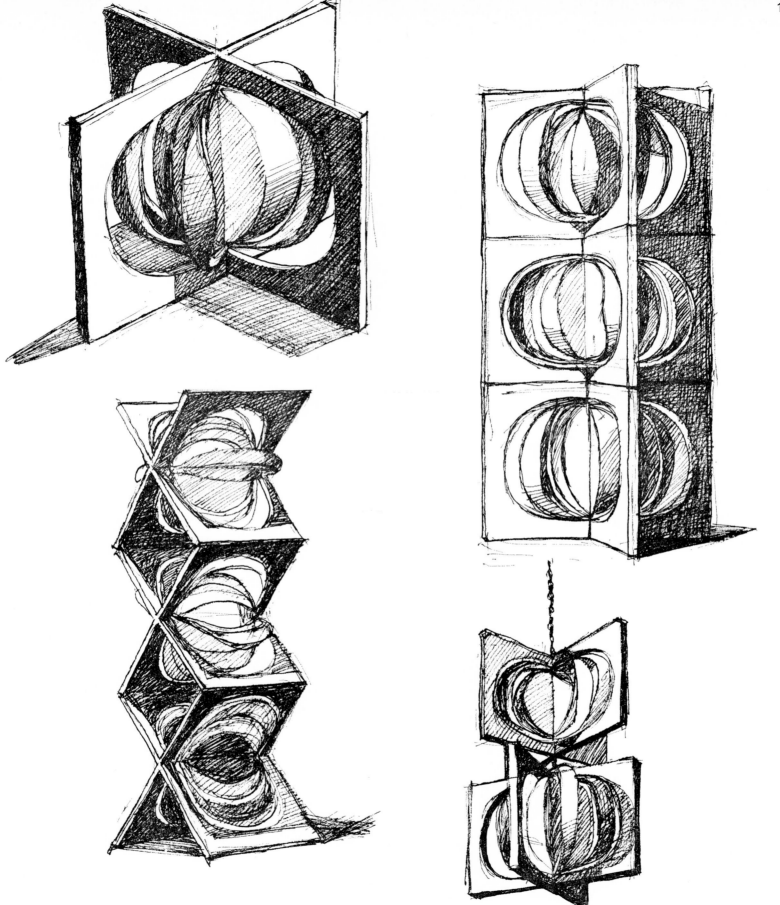

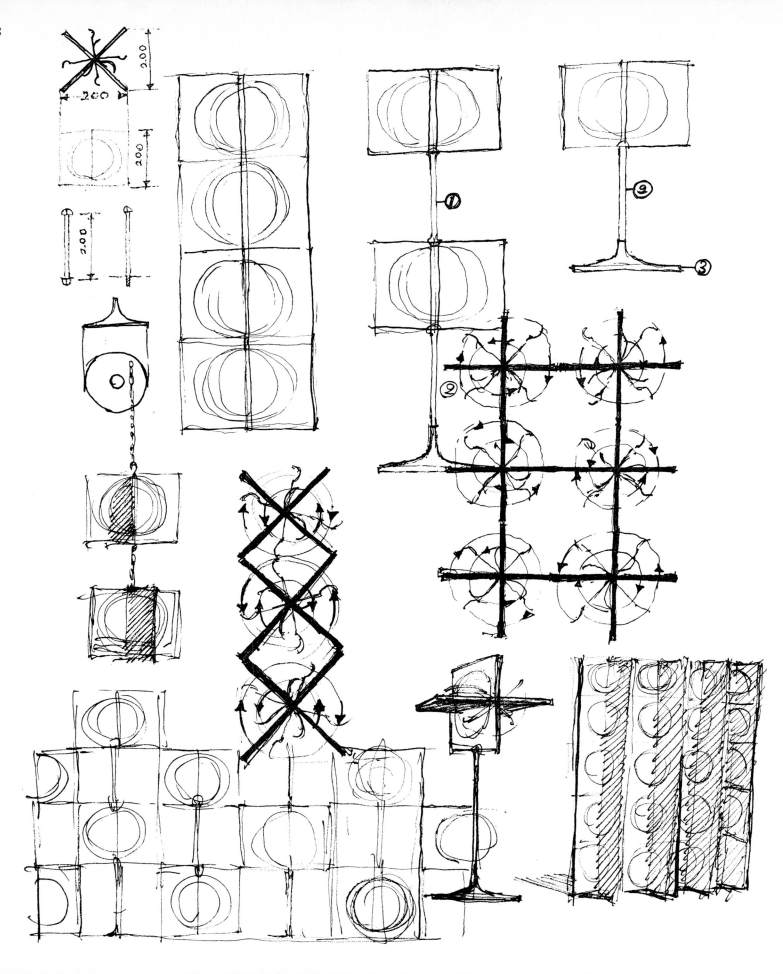

Water-Beat Garden. 1970

Stainless steel and molded plastics
pond length 62′11″; buoy height 2′5$\frac{1}{8}$″
fountain 4′2$\frac{3}{4}$″ × 7′ (diameter)
Koyodai High School, Ibaragi City, Japan

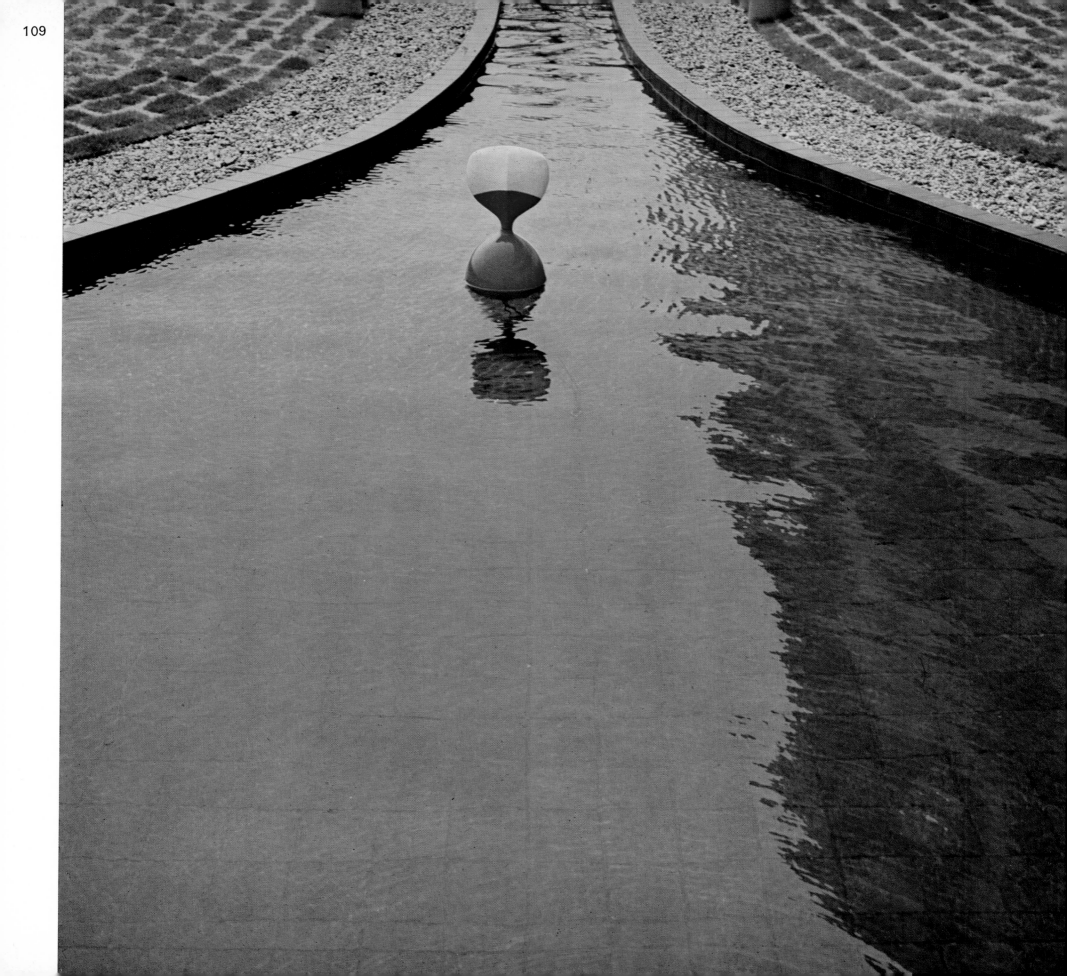

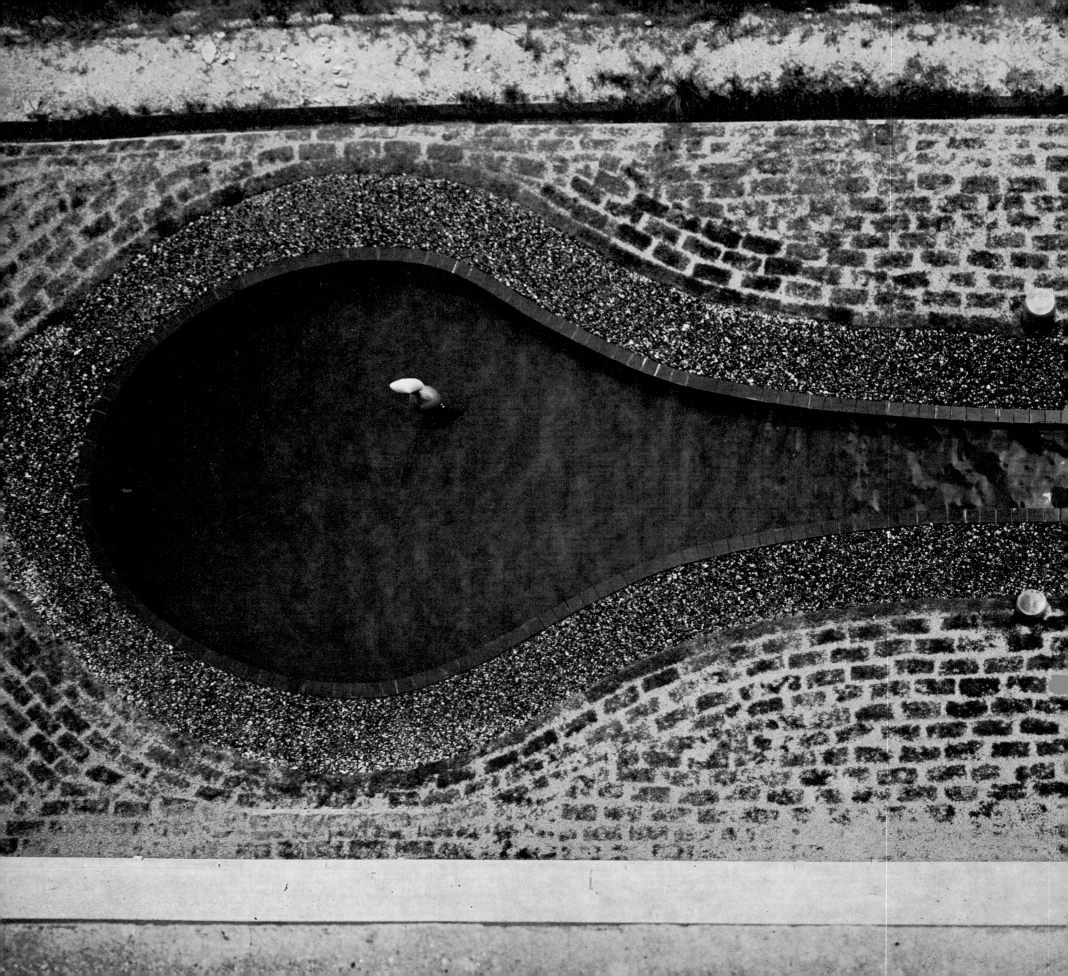

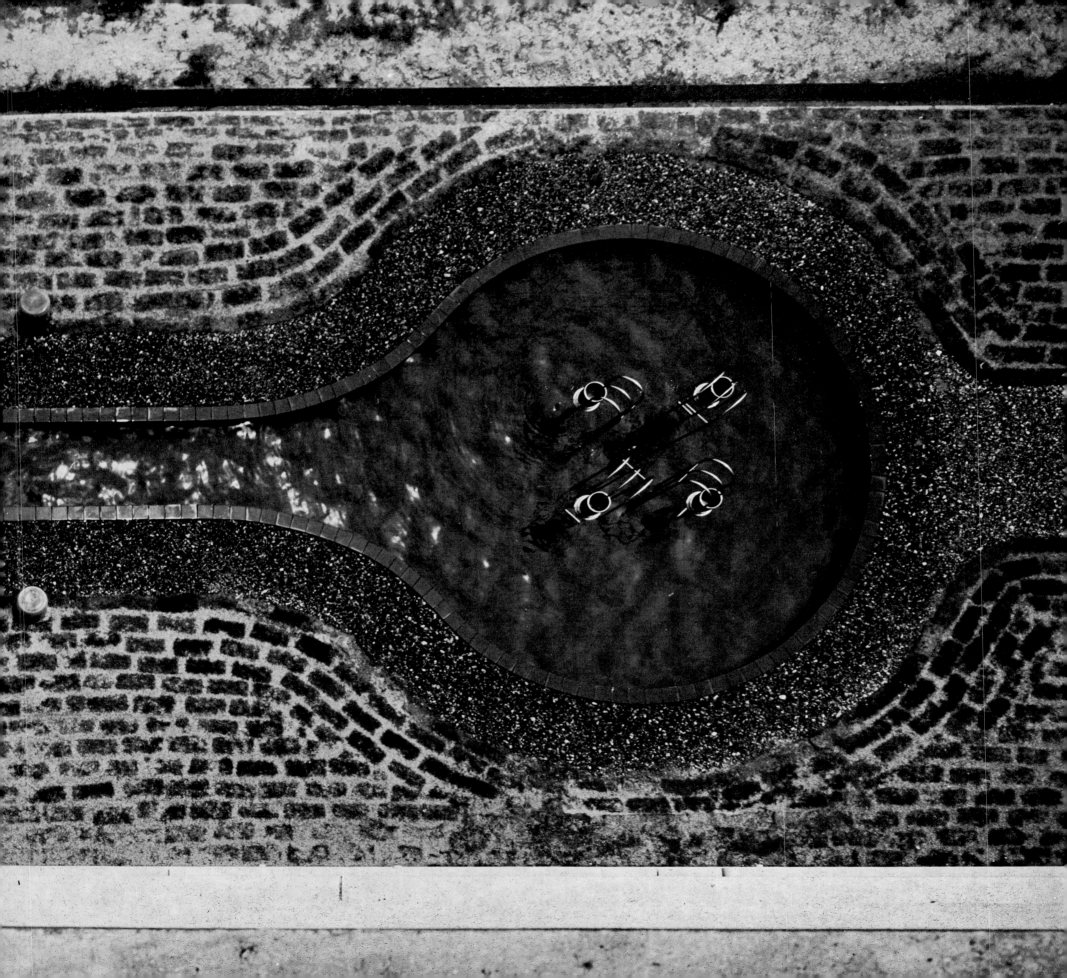

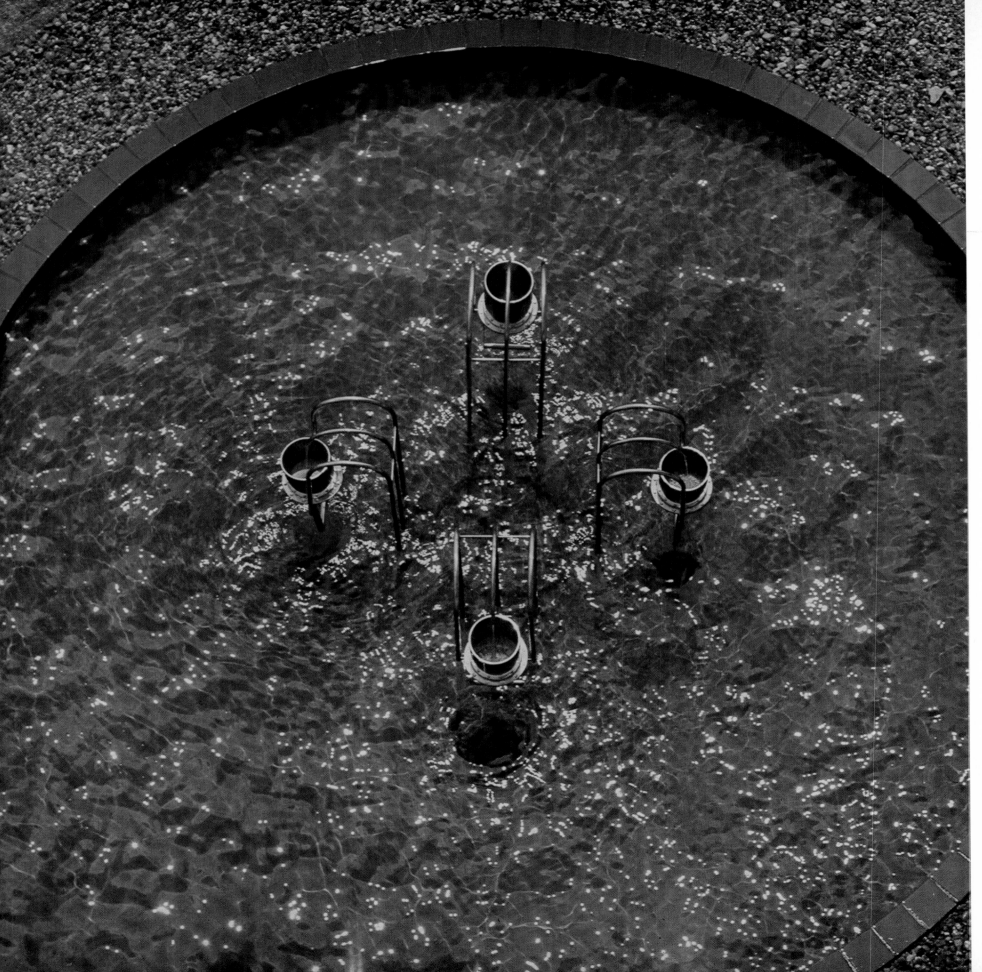

In one end of a gourd-shaped pond in the garden of an industrial high school is a moving stainless-steel construction; in the other end is a floating buoylike object. The multi-dimensional stainless-steel sculpture consists of four identical parts placed to form a cross when viewed from above.

Each of the parts is made up of three slender pipes and a cylindrical bucket. One of the pipes in each group carries a stream of water. As this water fills the buckets, they tip over, spilling their contents back into the pond. Brass plates attached to the bottoms of the buckets emit high, dry sounds as the water strikes them. Since the buckets are cylindrical the sound echoing inside them alters subtly in quality. Furthermore, since the movements of each bucket differ from those of all the others, so do the sounds emitted by each. When, grown heavy with water, they whirl upside down to empty into the pond, they set up ripple patterns on the water's surface. These gradually expanding patterns create a current that moves slowly to the circular section at the far end of the pond. This motion in turn causes the buoy, which is always headed into the wind, to bob about. Just as one catches the high, dry sound of the stream of water striking the brass plate of one bucket, a full one turns end up and loudly splashes its contents into the pond. The alternating sounds produced by the four buckets create the strange harmony that is the charm of this work.

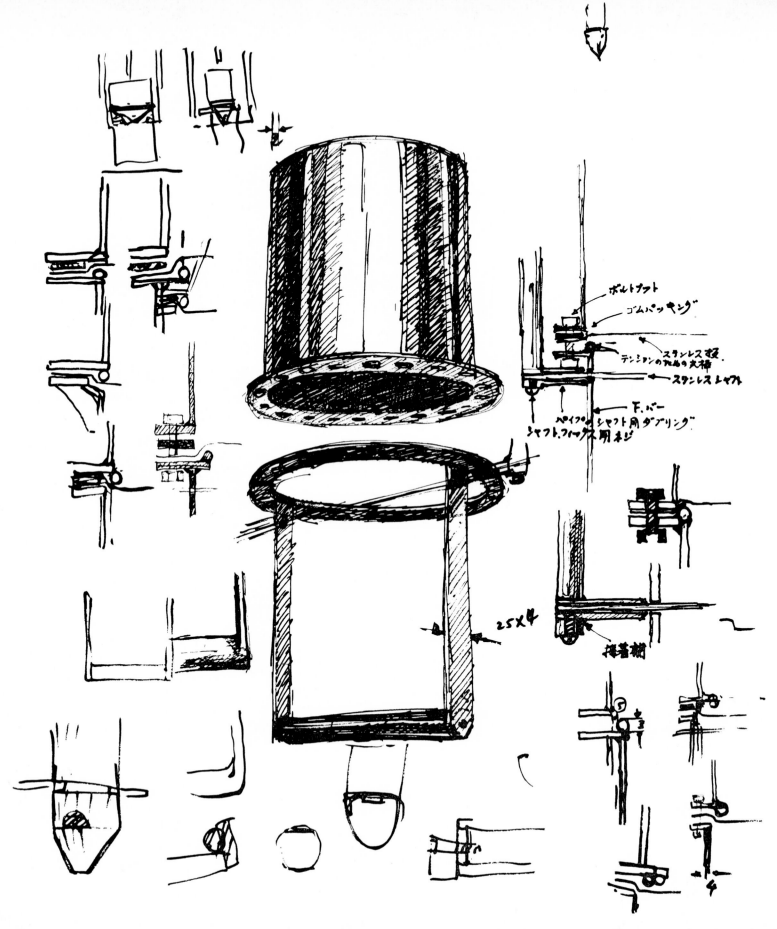

ボルトナット

ゴムパッキング

ステンレス板

テンションのための丸棒

ステンレス シャフト

F.バー

パイプ シャフト用 ダブリング

シャフト、フィーグス用 ネジ

25×4

接着剤

Belfry on the Water (model). 1970
Projected size 65′7″ × 131′2″ (diameter)

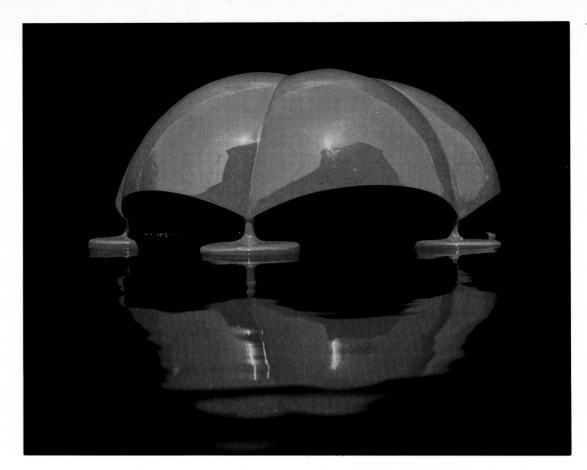

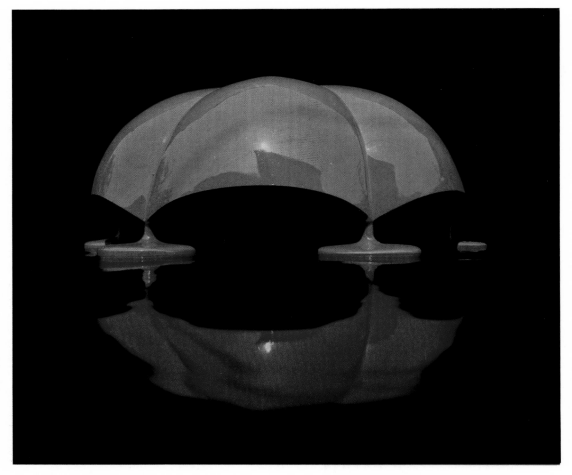

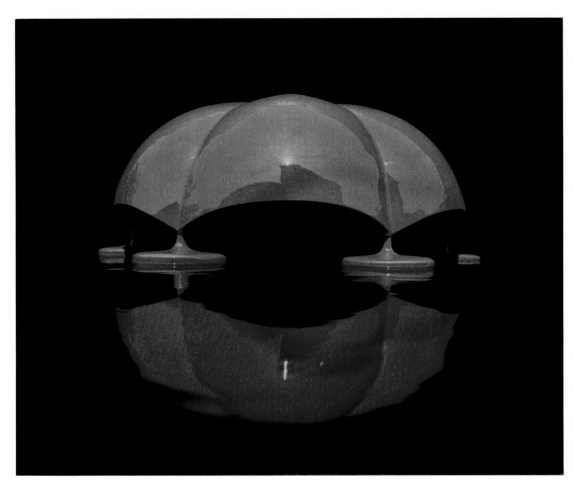

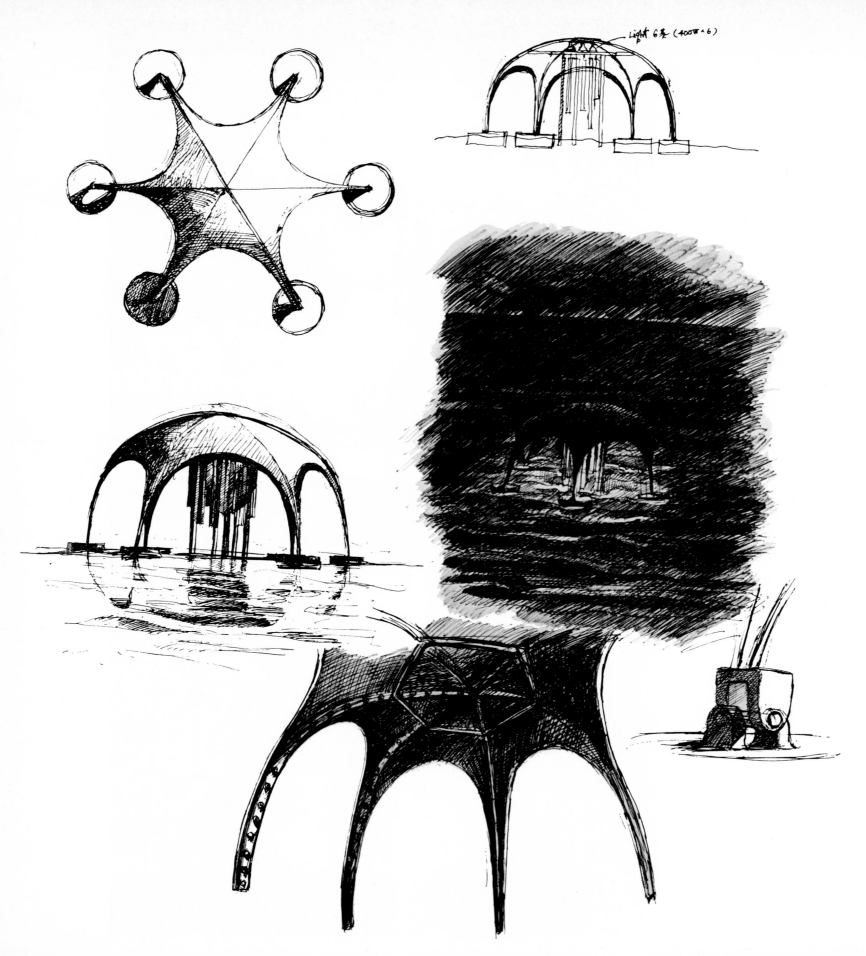

Light 6套 (400W×6)

This domelike structure is designed to float on water. Since the roof is made of reinforced translucent polyester resin, at night the light fixtures inside the dome transform the entire work into a luminous body. Other equipment inside the structure emits sounds that reverberate under the dome. Chainlike anchors hold the dome in place while permitting it to float on the surface of a lake or the sea. Since the plan stipulates a dome approximately twenty-one yards high and forty-three yards in diameter, swimmers would be able to experience the interior lighting and sounds with intense directness. Multicolor illumination from the audio equipment together with the rippling surface of the water on which the dome floats would produce a highly complex impression.

In the Forest of the Myths. 1968
Molded plastics, wood, and aluminum
length 5′11¼″
Collection the Artist

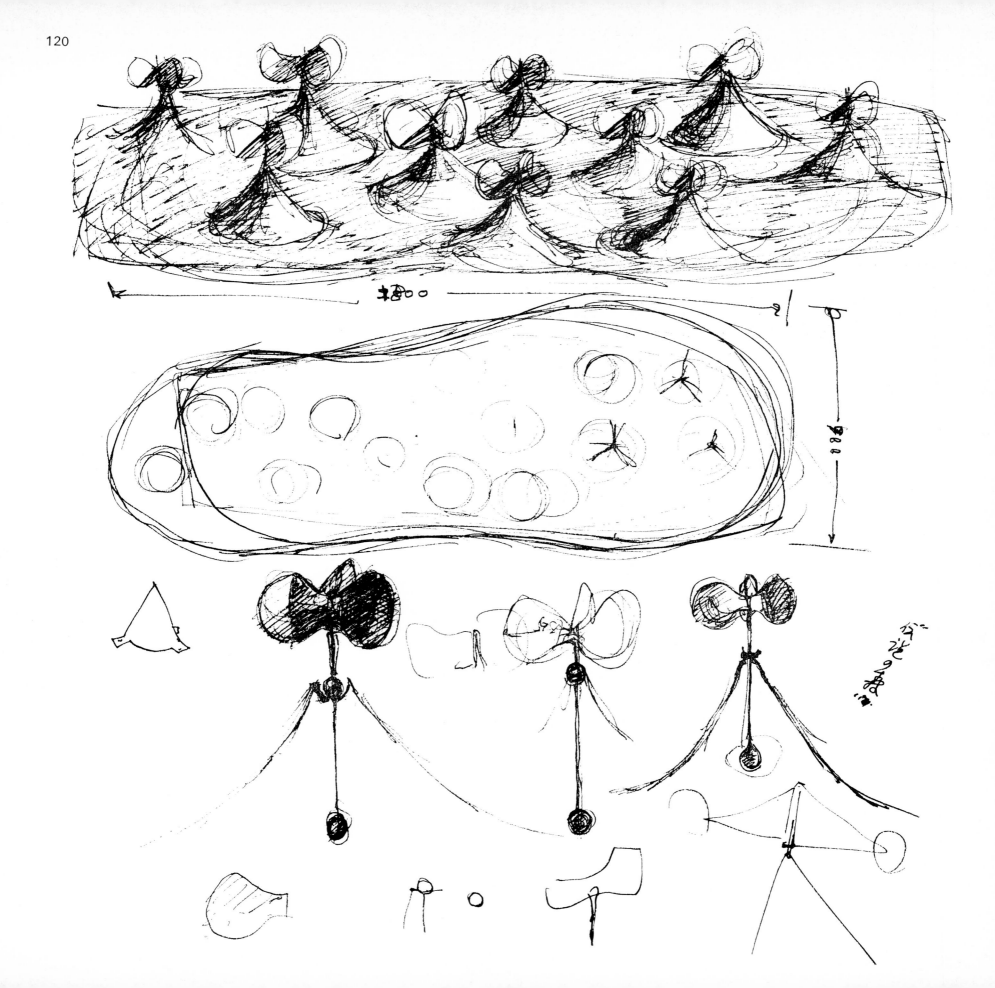

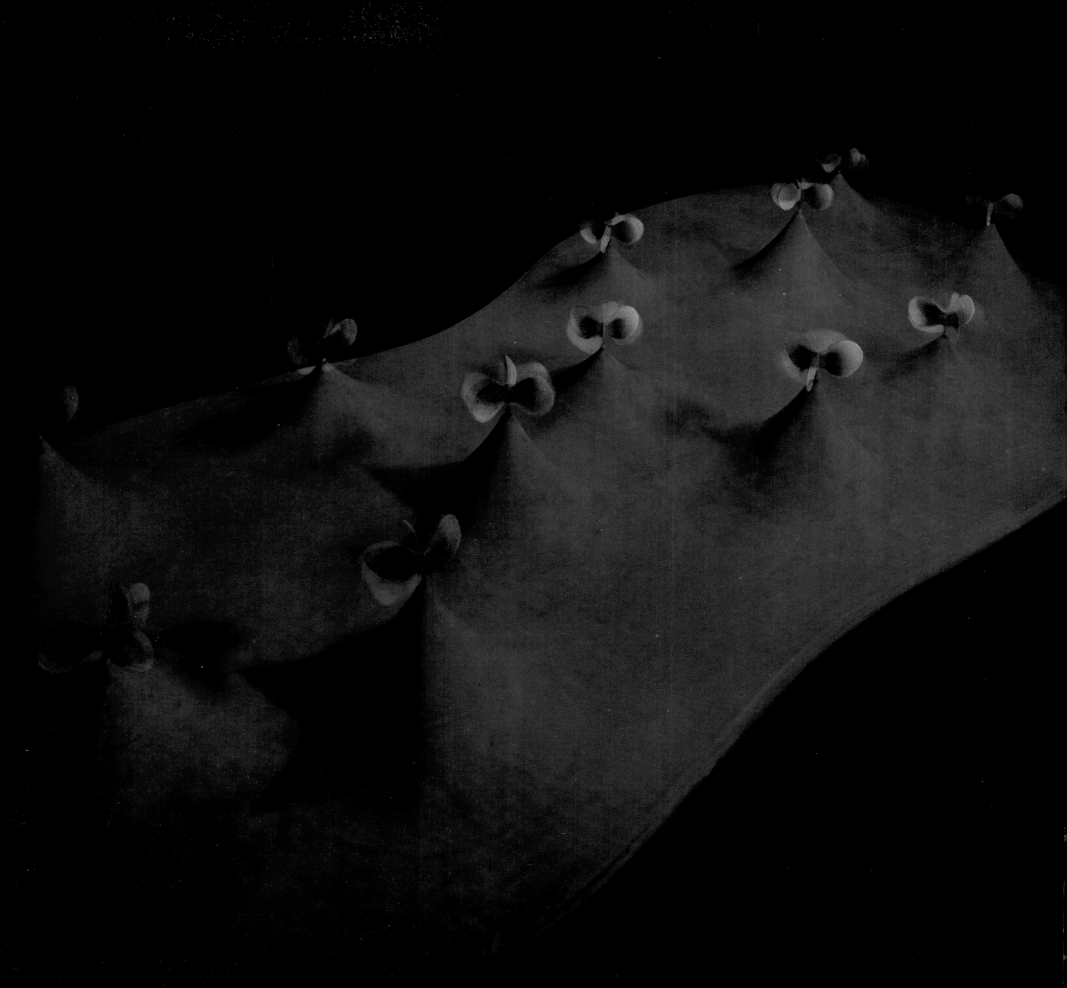

Fruit of the Wind. 1968
Molded plastics, steel, and stainless steel
height 9′3″
Rissho University, Kumagaya, Japan

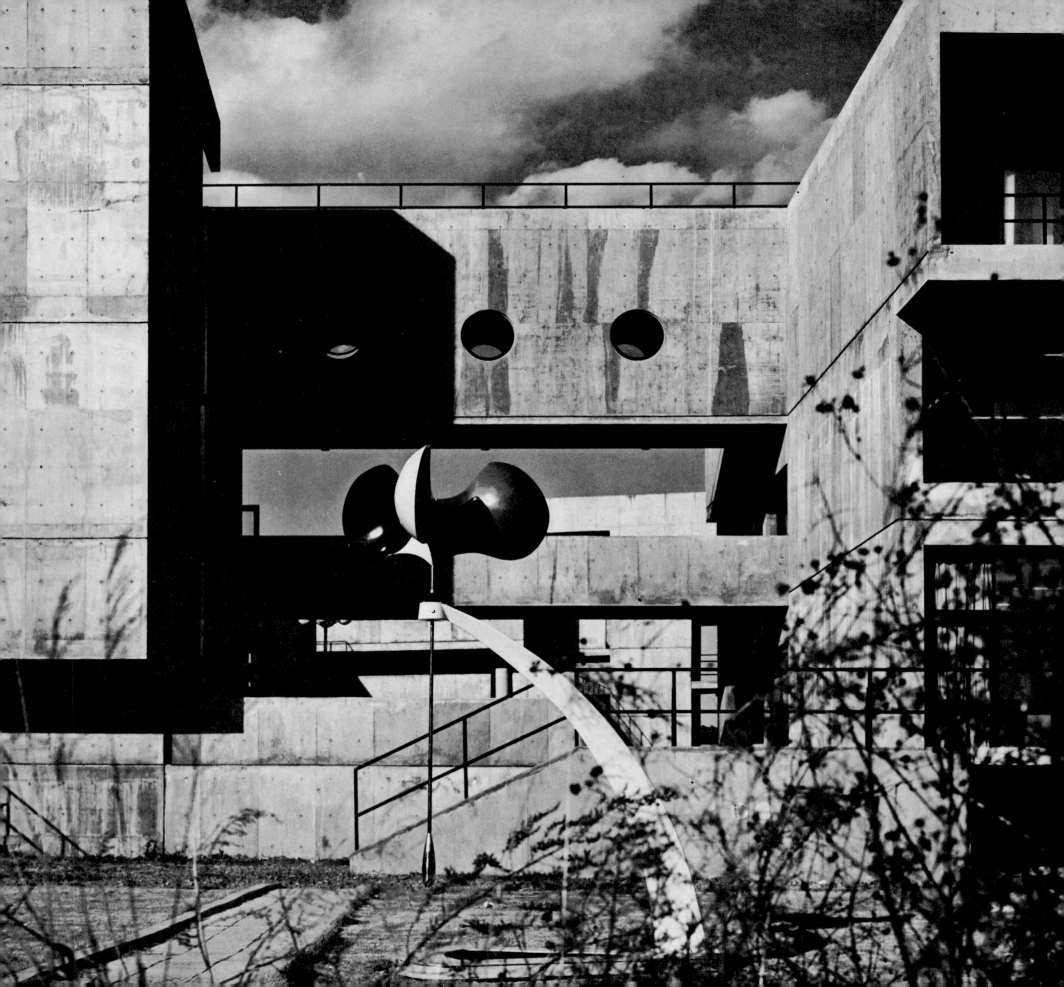

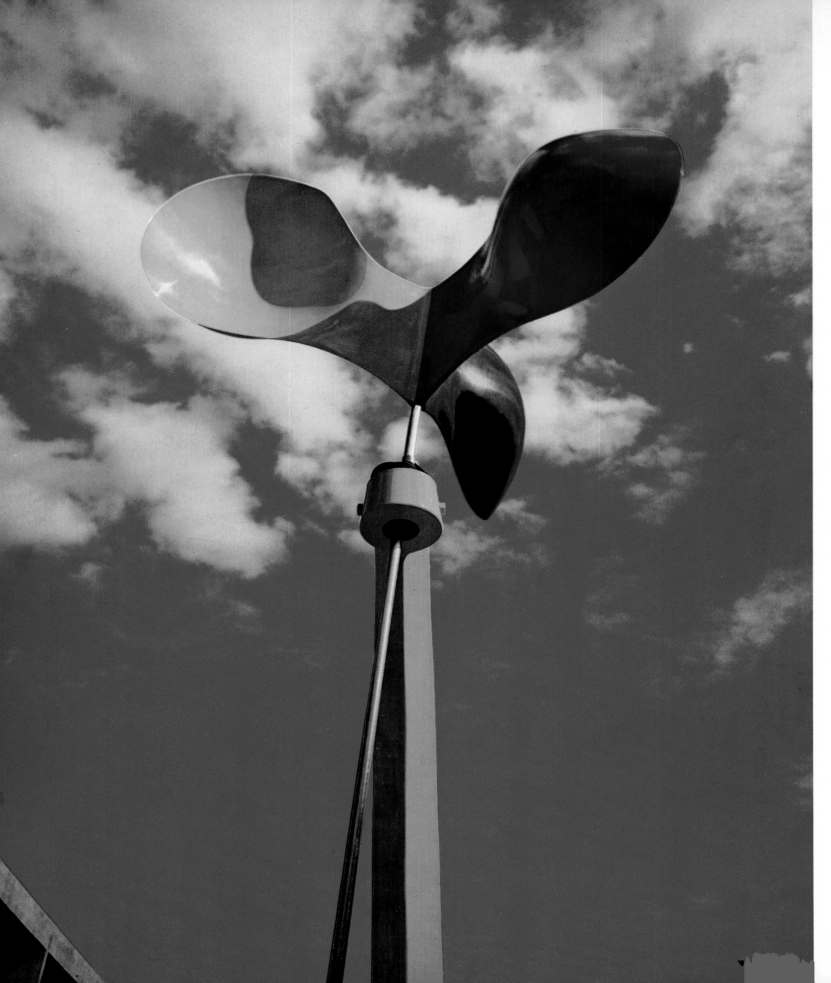

Floating Sound (created for Osaka EXPO '70). 1969
Molded plastics, wood, and steel
11′4″ × 48′7″ (overall diameter)
Sonoda Racetrack, Hyogo Prefecture, Japan
(photographed in the Lake of Progress at EXPO '70)

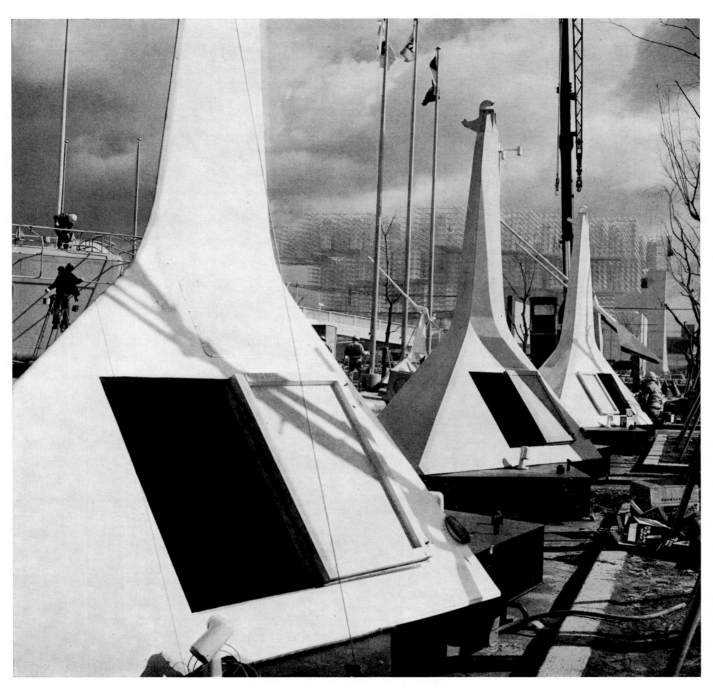

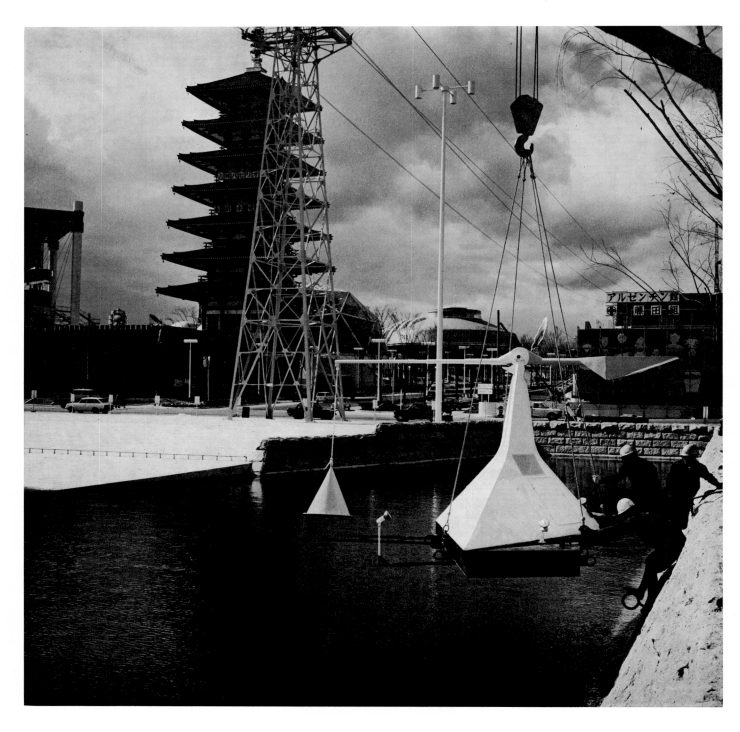

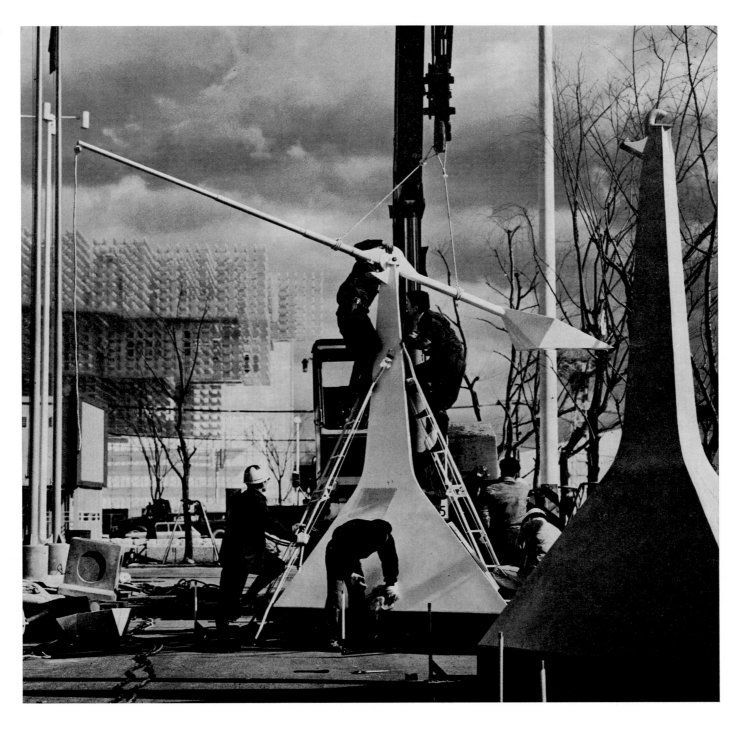

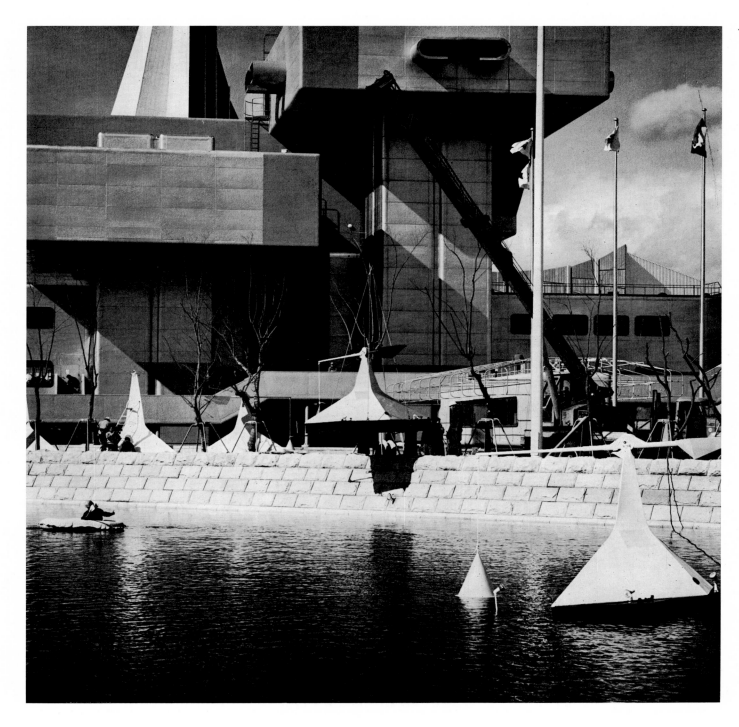

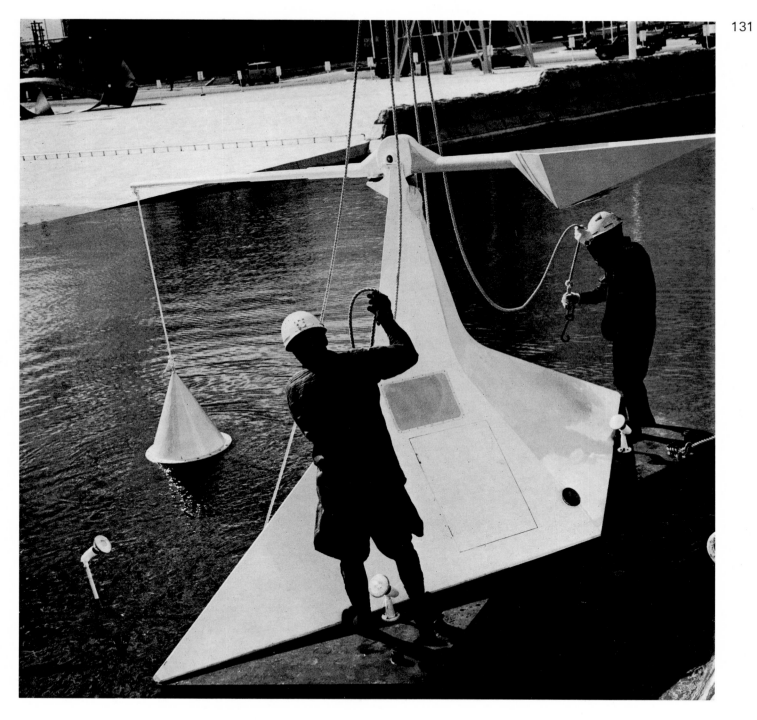

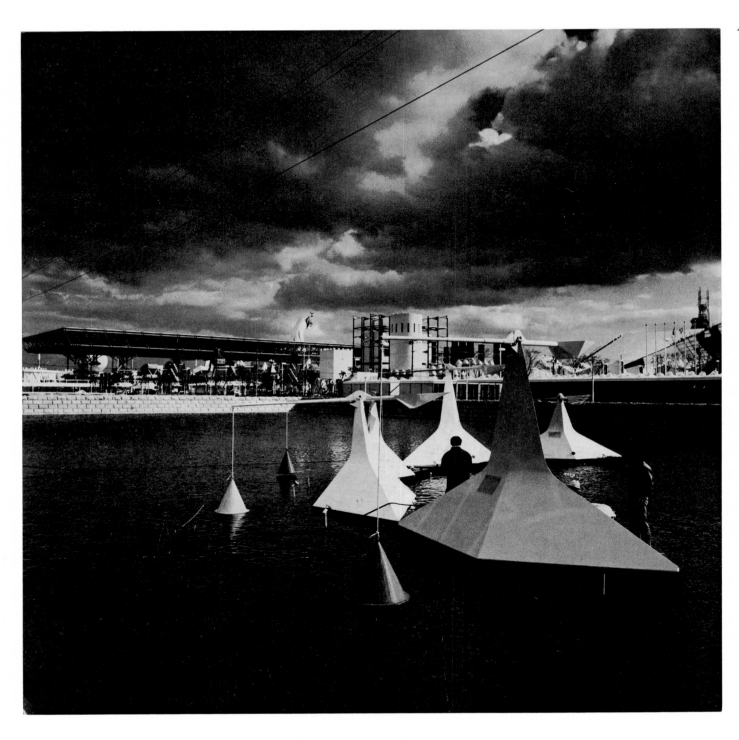

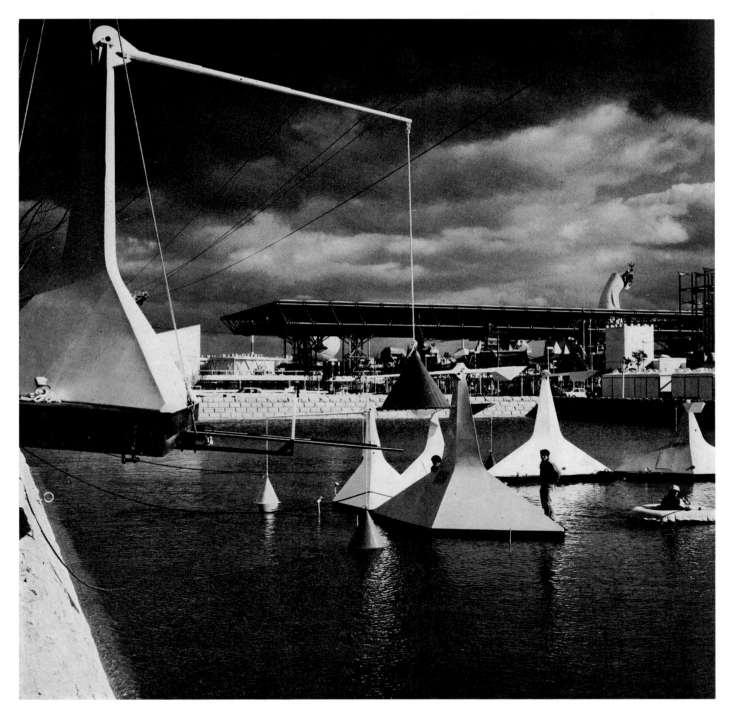

In this expansion of the ideas treated experimentally in *Duet* (p. 184), Shingu has succeeded in giving splendid realization to his intention of combining and multiplying the effects of sound and water. Six regularly placed units float on the surface of the pond. Seen from above, they form a hexagon. Just as in *Duet*, each unit is fitted with a kind of seesaw arm with a scoop at one end. When the motors start, water is pumped into the scoops, which, gradually filling, tip to pour their contents back into the pond. When this happens, the cone on the opposite end of each seesaw is raised naturally in the air, only to fall smacking onto the water when the emptied scoop swings back to its normal position. Microphones concealed in the cones transmit the sound of the cones striking the water across the entire surface of the pond.

Because the individual structural units move at different times, the spilling of the water and the concurrent smacking sounds occur at staggered intervals. Monotony would no doubt result from this simple process if there were only one unit, but the variety resulting from the simultaneous action of all six renders the total impression complex and interesting. In spite of the multiple action, however, a crisp rhythm is preserved. The ability to achieve this effect successfully is a distinctive charm of Shingu's work.

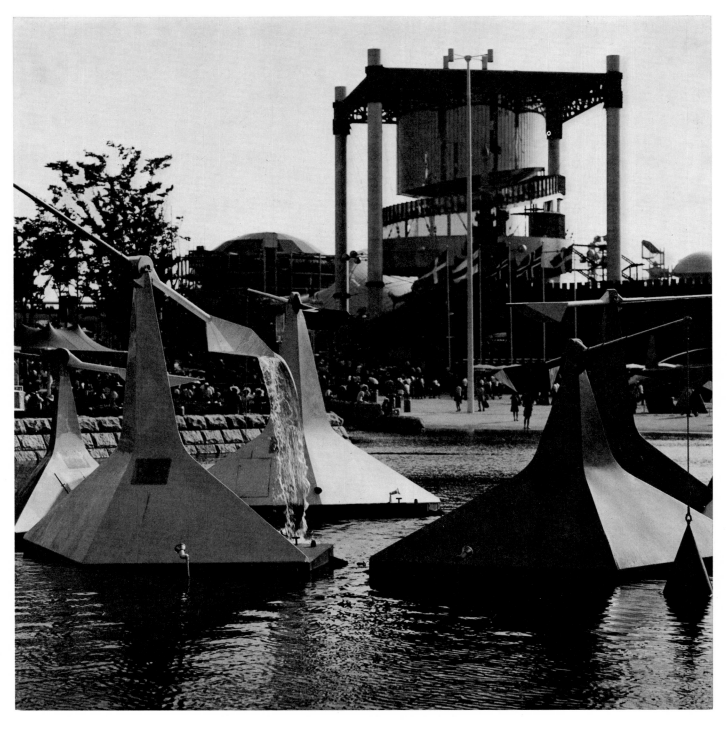

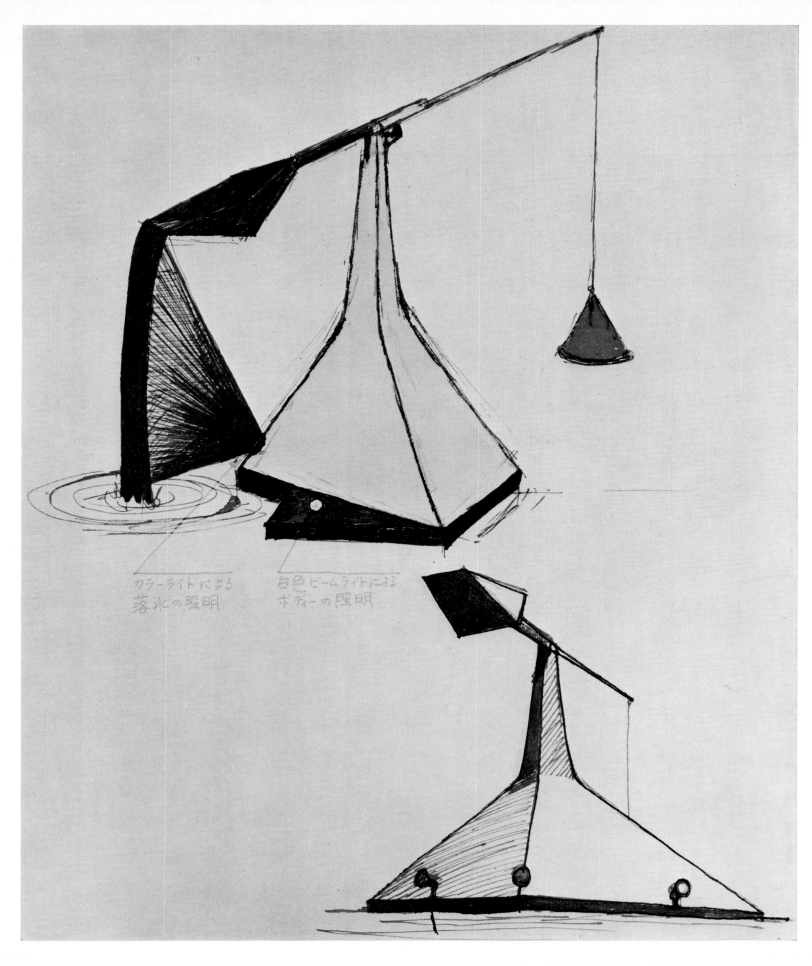

カラーライトによる
落水の照明　　　　　　白色ビームライトによる
　　　　　　　　　　ボディーの照明

Easy-Going Cloud. 1967
Molded plastics and steel, height 55 1/8″
Collection the Artist

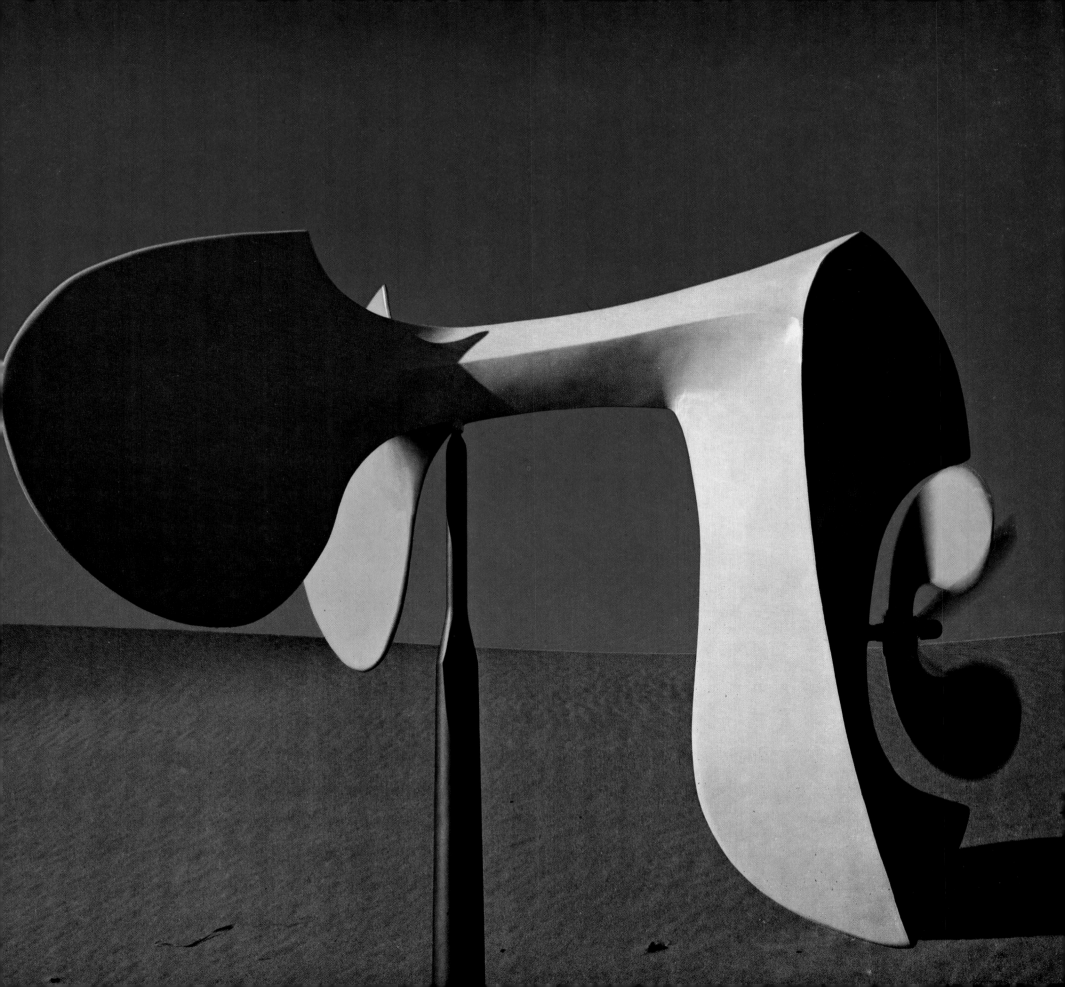

Breathing Cloud. 1971
Molded plastics, stainless steel, and felt
6'1/2" × 3'11 5/8" (diameter)
Fukuoka Sogo Bank, Tokyo

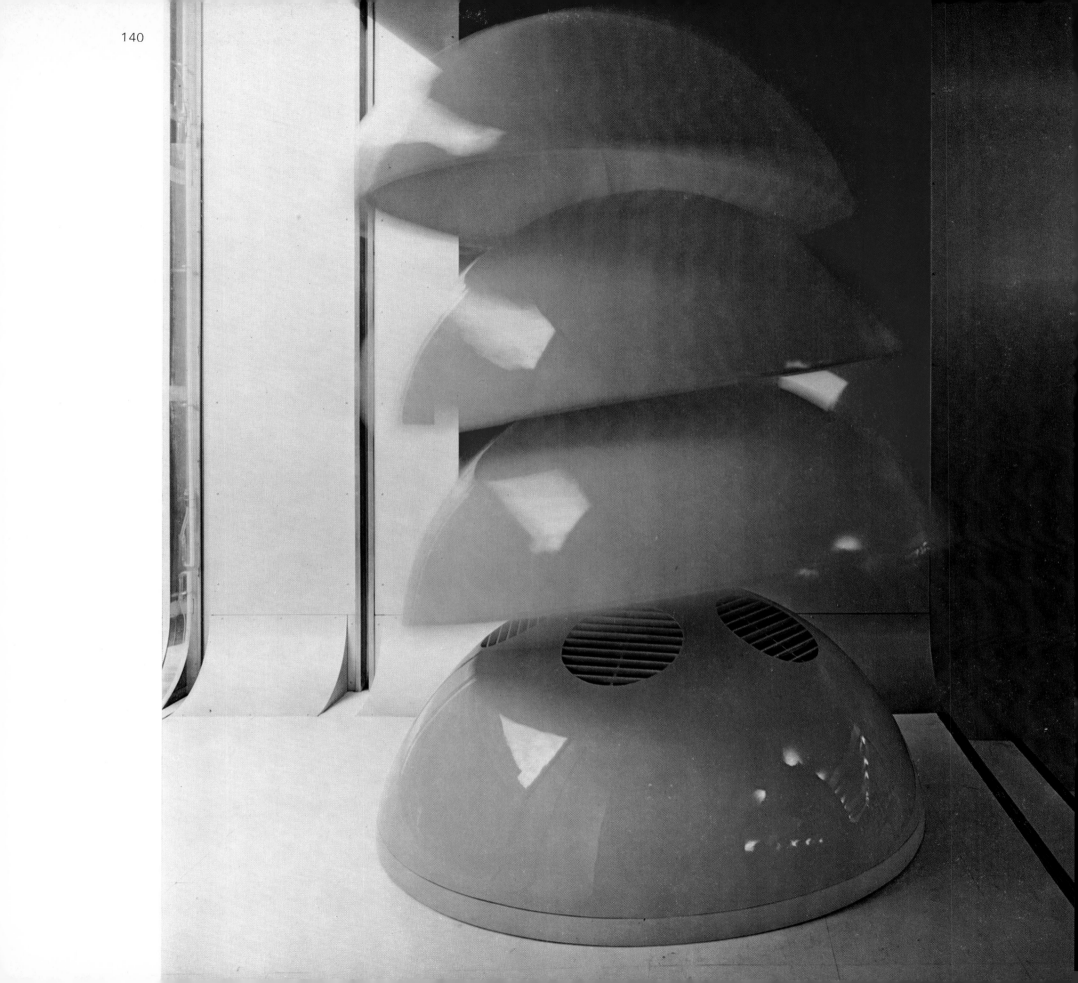

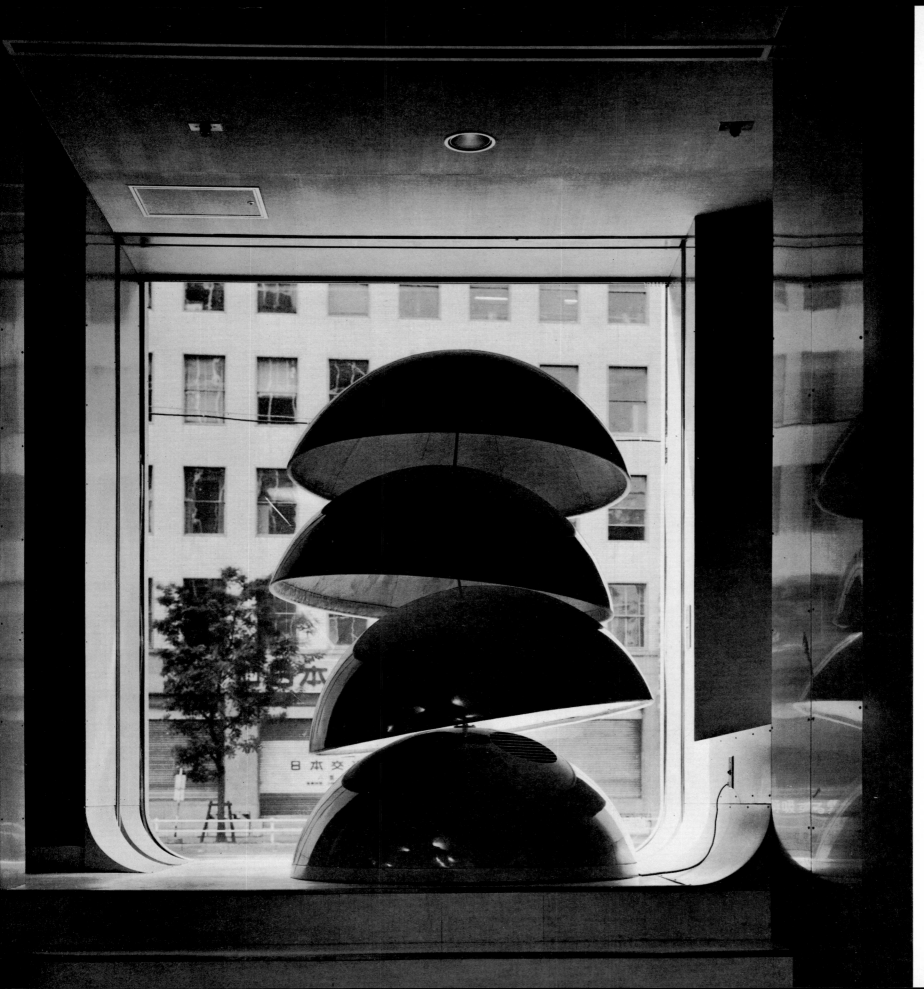

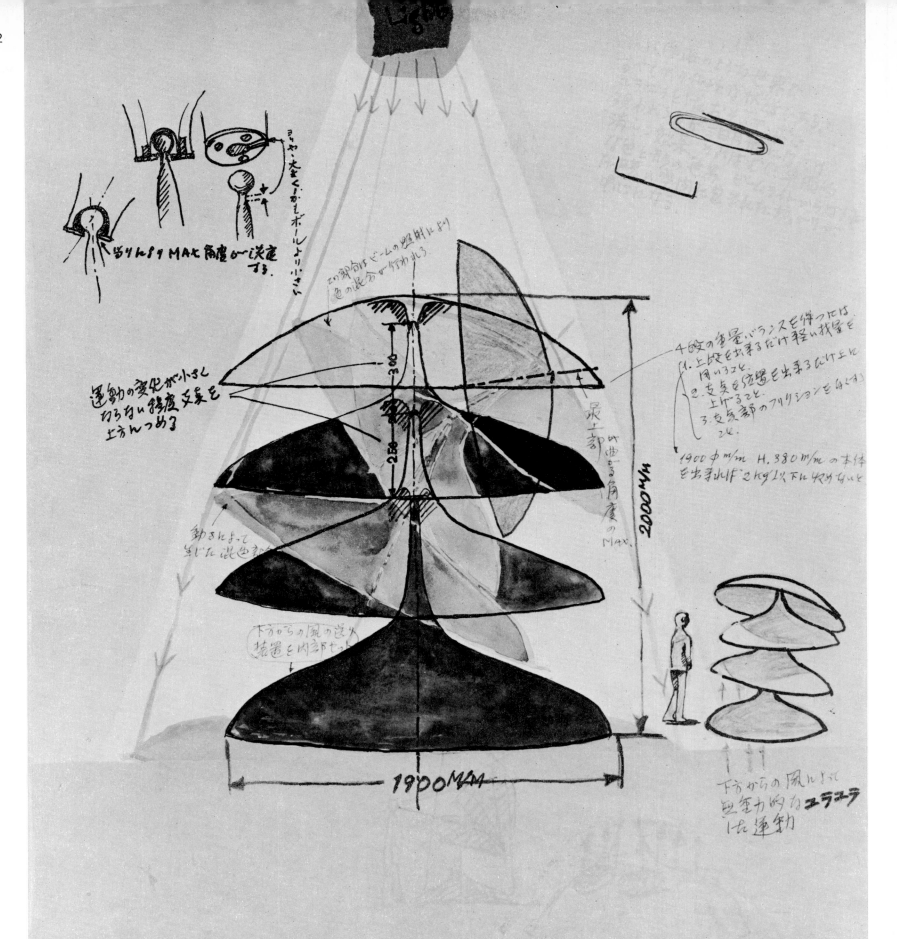

Duet. 1968
Molded plastics and steel, length 7′ 4 3/4″
Collection the Artist

As it floats on the surface of the pond, *Duet* draws water upward and allows it to flow out again. The boatlike oval central section is fitted at each end with a projecting pipe to which is attached a horizontal piece vaguely resembling a pair of scales. At one end of each pair is a scoop; at the other is a conical device containing a microphone. The latter hangs in such a way as to come into contact with the surface of the water and also doubles as a counterweight to the scoop. In the center of the oval is a motor, which draws water from the pond and forces it into the scoops. When the scoops are full, the scales tip and allow the water to flow back into the hollow center of the oval. The entire operation is transformed into sound by means of the microphones. For instance, when the microphone ends of the scales strike the water, the equipment emits loud sounds. However, since the sounds from the microphones differ, the two identical scales perform an actual duet of varied movements and dissimilar tones. Perhaps more than any other work *Duet* is a subtle and compelling statement of Shingu's harmonious view of the natural world.

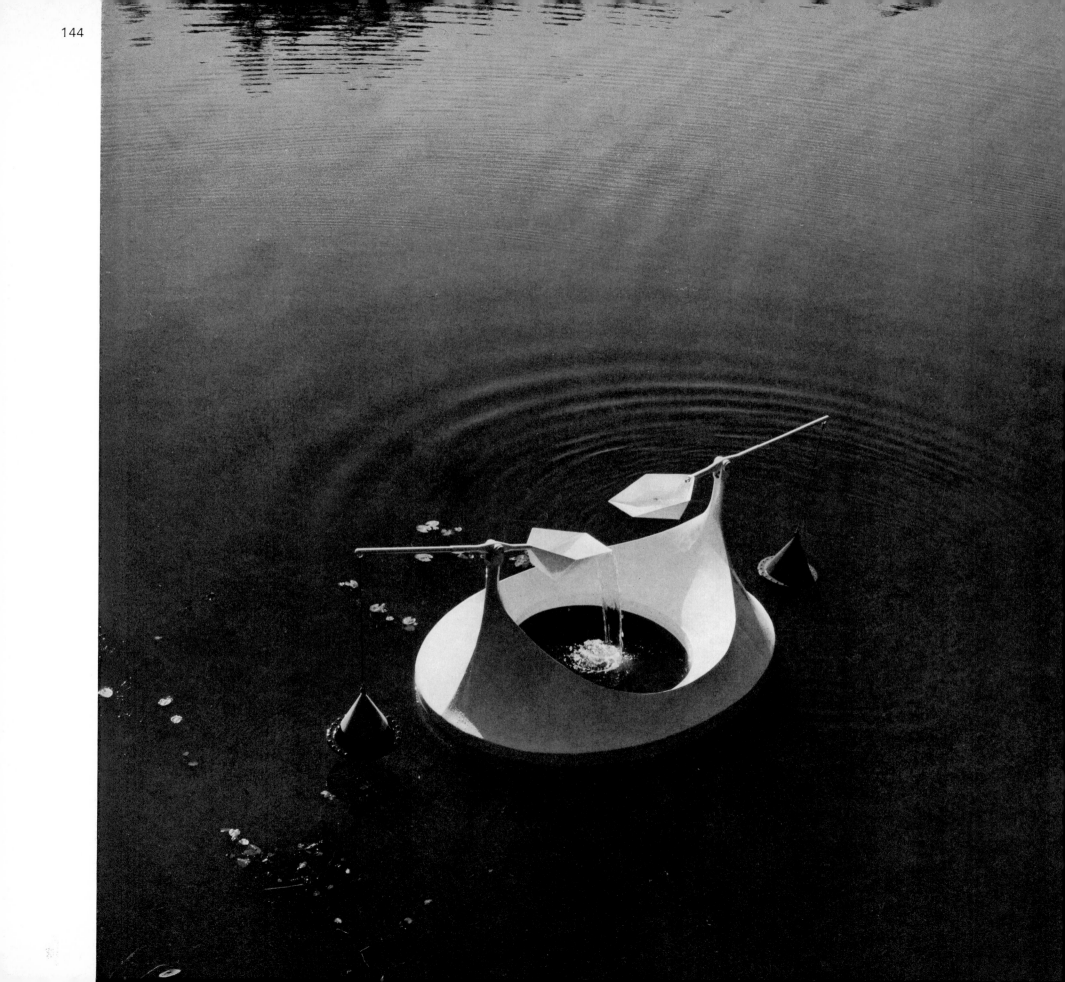

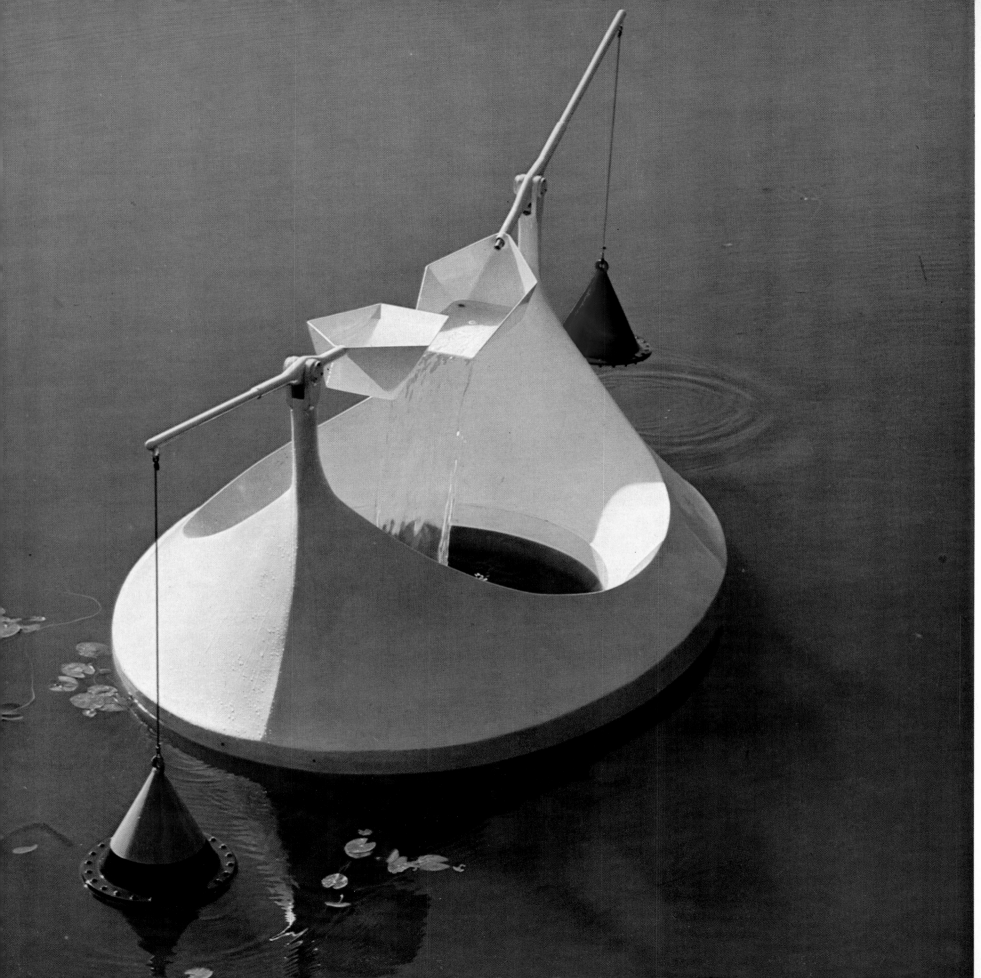

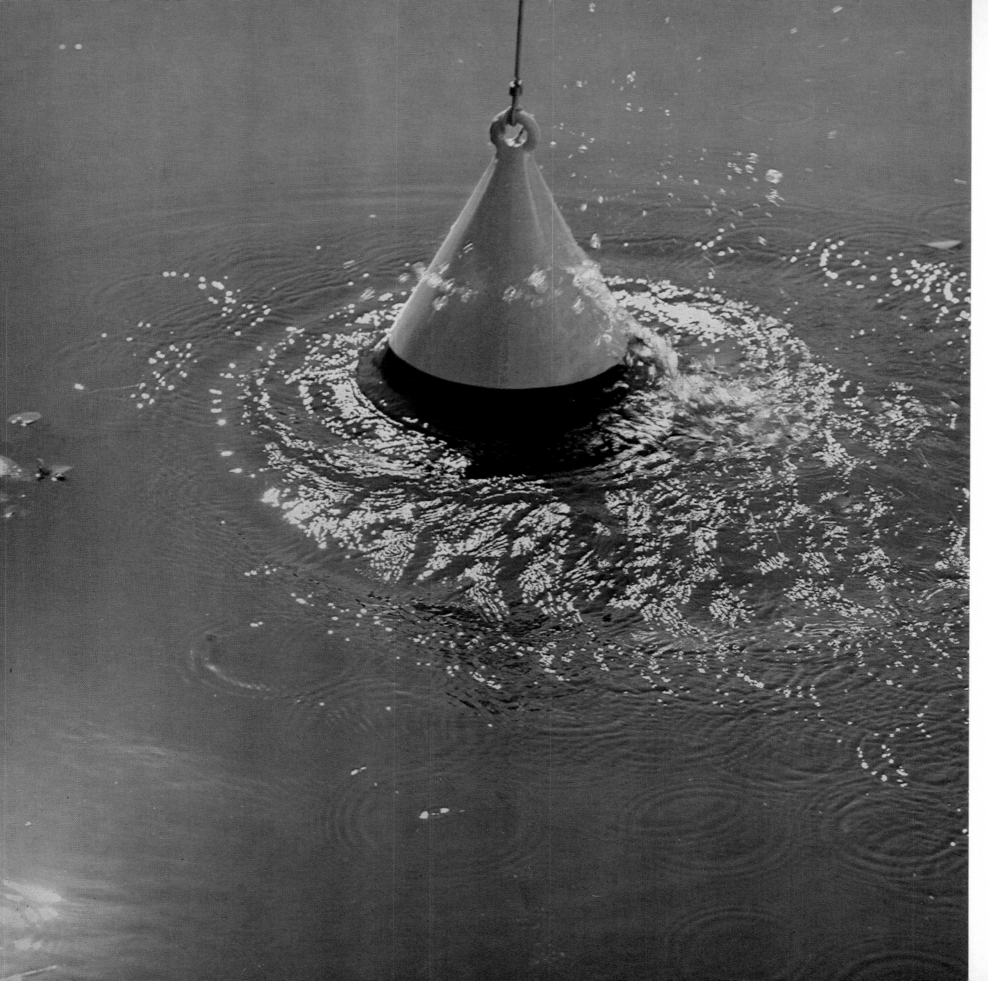

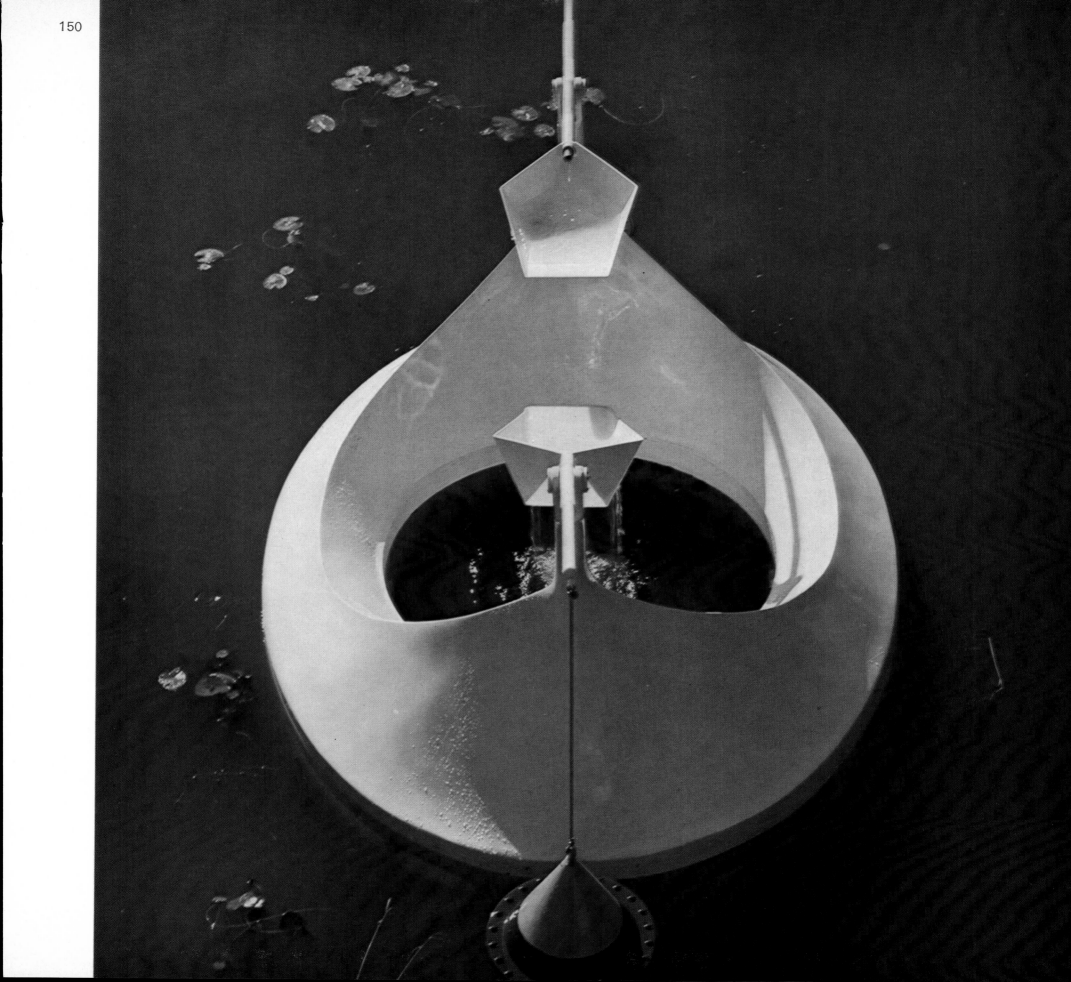

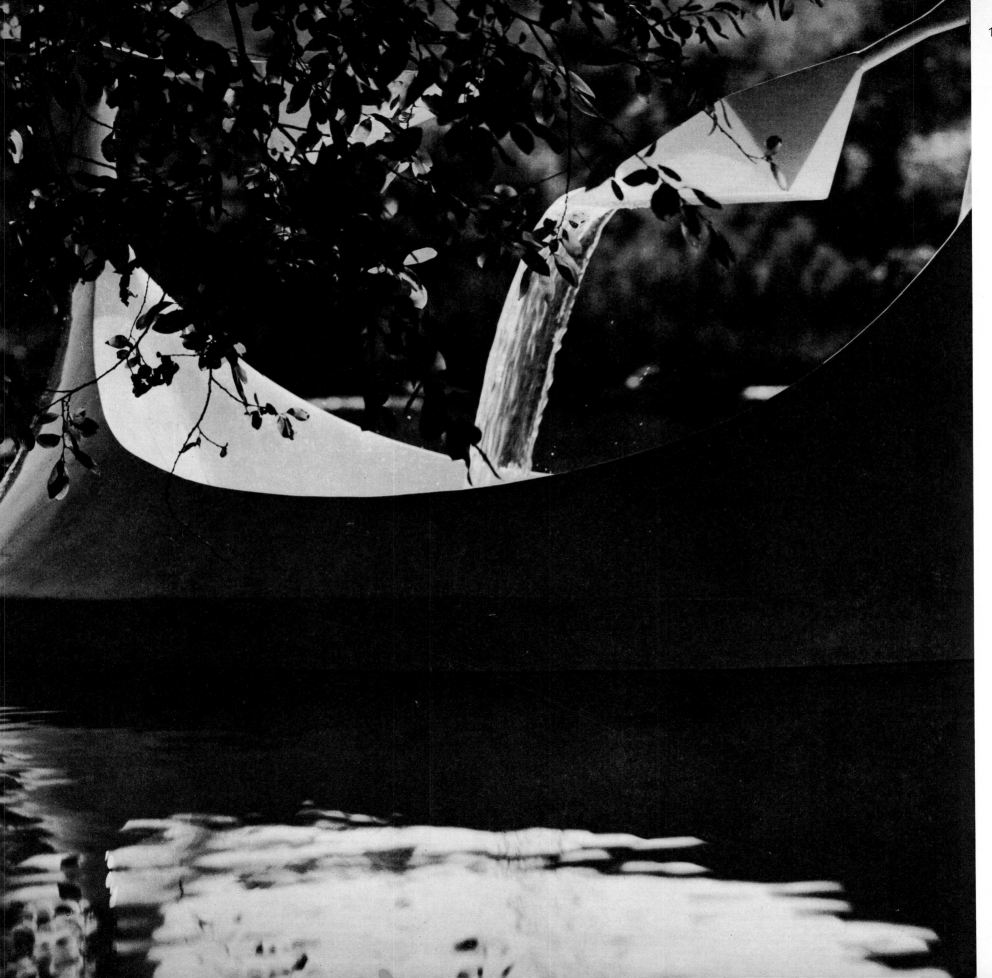

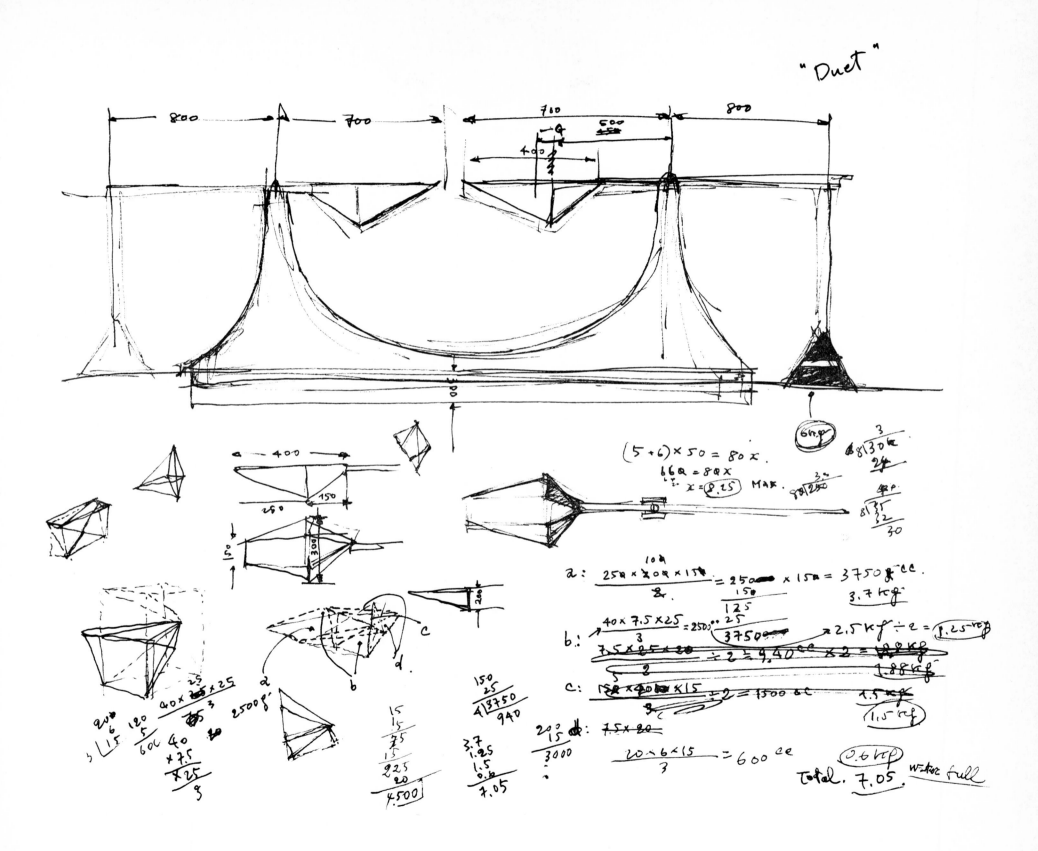

"Duet"